Desires and Disguises

Desires and Disguises

Five Latin American Photographers

EDITED AND TRANSLATED BY
AMANDA HOPKINSON

Library of Congress Catalog Card Number: 92-60144

British Library Cataloguing in Publication Data

Eleta, Sandra
 Desires and Disguises
 I. Title II. Hopkinson, Amanda
 779.092

 ISBN 1-85242-280-7

First published 1992 by
Serpent's Tail
4 Blackstock Mews, London N4, and
401 West Broadway #2, New York, NY 10012

Typeset in 10½/14 pt Goudy by Contour Typesetters, Southall, London
Printed in Great Britain by Longdunn Press Ltd, Bristol

Contents

To my sons and my sisters

Desires and Disguises

Acknowledgements

First of all, considerable gratitude is due to the photographers participating in this book and in the exhibition *Desires and Disguises* and to Elena Poniatowska for providing the introduction. All had to work hard in their home countries, in Europe, and within their own crowded schedules to meet deadlines and afford the lengthy interviews necessary for the 'portrait chapters' in this book. Many thanks not only for your patience and hard work, but also for the assistance and hospitality shown when I visited, interviewed and selected work with you.

It has been a pleasure to work with Ruth Charity and Sue Grayson Ford at the Photographers' Gallery. Again, the logistics of long-distance communications have tied us into more meetings than any of us anticipated, but your willingness to put in the extra hours, and sensitivity to the issues raised by another 'new departure' for the Photographers' Gallery and the importance of seeing Latin America documented by Latin Americans in 1992 has been much appreciated. This has also been a different kind of book for Serpent's Tail to undertake, and Pete Ayrton and John Hampson's flexibility and diligence in dealing with a host of unexpected hitches and delays has made it a far less arduous and isolating project than it could otherwise have been. Thanks too to Sarah Podro for transcribing the interview tapes, yet again at short notice and under pressure.

Thanks also to my children, Rebecca, Luke, Jake and Joel, who suffer my unsocial working hours and journeys abroad with more-or-less good grace and are always welcoming and companionable to return to. It must be particularly difficult to tolerate an abstracted parent when you cannot (yet) understand what all the fuss is about. I hope very much that seeing *Desires and Disguises* will help you to do so. Thanks also to Pete Binns, Bob Gilbert, Sara Burns and Clara Inés Cantillo who adapted and helped, often at short notice, to care for the children.

Finally, when things got sticky at the Mexican end of things, I owe a special debt of gratitude to Peter Chappell, Holly Aylett and Dr Raúl Ortíz y Ortíz, cultural attaché at the Mexican Embassy in London. Not to mention Nick Caistor, for providing the title. Without the above, you would not now have this book in your hands.

Amanda Hopkinson

Preface

1992 marks the five-hundredth anniversary of Columbus's arrival in the Americas and the beginning of a long history of European influence upon this continent. It is a year in which Europe has turned its attention across the Atlantic and considered its own part in the shaping of America's political and cultural development. Columbus and his so-called 'discovery' has been celebrated, written about, filmed and debated. Things Latin American – from Mexican beer to the tango – have been imported and enjoyed: for a year the continent takes centre stage.

However against this background of Eurocentric celebration, many Latin Americans take a counter standpoint. They view the quincentenary as a time for reflection on the repression of, and resistance to, five hundred years of European imperialism. Questioning the notion of 'discovery', they have cited 1992 as the time to draw attention to and celebrate their own cultures.

The Photographers' Gallery exhibition *Desires and Disguises*, upon which this book is based, has set out to look at Latin America not from a European perspective, but through the eyes of its own people. Five photographers – from Mexico, Guatemala, Panama, Argentina and Chile – have been selected to show their work on distinct communities within their country. They do not however look back at an untainted indigenous culture; instead they reveal the complex cross-fertilization of cultures that exist within this ever changing continent.

María Cristina Orive reflects on the assimilation of one culture by another. In her work on the syncretic religious celebrations and processions in Antigua, Guatemala, she examines the curious fusion of Roman Catholicism, brought by the Spanish in the sixteenth century, with the rites of indigenous religion. In contrast, Sandra Eleta looks at a culture that has travelled half way across the world but remains largely intact. In her series *Portobelo* she reflects on the life of a community descended from emancipated African slaves, who liberated themselves in the eighteenth century to establish their own free republic in Panama. Two hundred years later their lives are still based on a shared culture derived from ancient Yoruba religious practices in West Africa.

The United States has had a long history of intervention in Latin America and Graciela Iturbide's study of Mexican street gangs in Los Angeles considers one aspect of this often uneasy relationship – the influence of the States upon neighbouring Mexico and its mirage-like attraction for those seeking a better way of life. Iturbide's work investigates the lives of the many Mexicans who cross the border to find work and, faced with the impossibility of making a living, join street gangs and work the subways.

Not all Latin American countries have retained a precolumbian identity. Indeed Sara Facio's work on the street life of Buenos Aires reflects the great cultural mix of people there, many Italian in origin with a wide mixture of other European nationalities who have flocked to the port over the past one hundred and fifty yeras.

The marginalization of minority groups is a widespread and ever present issue. Paz Errázuriz's work considers those who live on the edge of society in Chile, the outcasts or outsiders – gypsies, circus performers, boxers, and others – who use forms of dressing up and disguise to create new personae for themselves.

Desires and Disguises was not initially conceived of as a 'women's show', still less as a 'feminist platform', however valid such concepts are and whatever the different ideological positions of the participating photographers. In this context, that would be to marginalize the work that was selected primarily because it conformed to our first criterion of being by Latin Americans on Latin America, rather than another set of pictures taken by westerners of the 'other' – the exotic and

exciting – that we so often come up with on our journeys of cultural tourism. Secondly, the work chosen fitted what turned out to be the taller order of documenting a particular community, whether cultural, ethnic or religious, from within the photographers' countries of origin.

This excluded the (impossible) attempt of cramming either a representative sample from such a large and photographically prolific continent or even a 'celebration of richness and diversity' into a single book or exhibition. The wealth of Brazilian photography clearly deserves a future venue to itself. Other photographers were excluded for being among the 'Magnum boys' whose work was widely seen throughout Europe last year, the fiftieth anniversary of the agency's formation. Still other photographers, initially considered, themselves wished to be excluded, mainly because they had moved on from that form of documentation – or, in one instance, from photography altogether. This show therefore stands, not within the ghetto of 'women's work', but as work of a particular kind that 'just happens' to be taken by women – in exactly the same way that dozens of collective photography exhibitions and books have 'just happened' to only include work by men.

The book has been constructed around two sets of images for each of the five photographers. One set contextualizes the written introduction to each photographer's work, based on in-depth recorded interviews, later transcribed and translated before being edited and reproduced with the photographer's agreement. Each second set of pictures is drawn from the main body of work shown in the *Desires and Disguises* exhibition. For these the only requirement was that every series should consider a community from the photographer's country of origin in order to provide a focus for the 'Latin American photographers on Latin America' theme that seems so apt in 1992.

Each of these five photographers offers an insight into one particular aspect of contemporary Latin American society, whether of cultural fusion or difference. In their own words they describe the pleasures and difficulties of working within these societies. Commenting on their own history and culture, they offer a personal perspective on the complex cultural influences that have shaped the lives of Latin American people.

Ruth Charity, *exhibitions organizer, the Photographers' Gallery*
Amanda Hopkinson, *exhibition curator and editor*

Image Hunters
ELENA PONIATOWSKA

Once there were warriors, Valkyries and Amazons; now there are image-huntresses. They roved across the great continent of the Americas, setting their sights, shooting and stealing people's souls. Photography is their medium of identification in the world, their means of expression. What do they photograph? People on the edge, the dispossessed of the earth, at the boundaries of the earth, the world's afterwords; they are never an integral part of the scene.

Over time women have learnt to see the essence of things, and St Exupéry tell us that essence alone is invisible. Fine — then Sandra Eleta sees the invisible, and not only sees it but endows it with a remarkable range and richness of tone. Photographs cannot disguise, only reveal the photographer's true intentions, granting them an aura beyond that of their simple existence; they become an embrace, a self-reference, a self-portrait. The Panamanian Sandra Eleta demonstrates what escapes us when we refuse to enter into ourselves – for who wants to enter into loneliness, abandonment? By now it's commonplace to mention the feline beauty of black bodies, their negritude, their fluidity compared to white skin that wrinkles from the elbows, turns to parchment and hangs in folds around white necks. The superlative grace of Sandra Eleta's fishing girls is confirmed by the gaze exchanged between woman and child. 'Black is beautiful.'

As a huntress, Sandra Eleta commits herself to the chase and lives among her fellow Panamanians. Portobelo is a port anchored in the Pacific where fleets from the New World arrived to sell fabric and trinkets, gold ingots and silver plate, nearly weighed down to the floor of the ocean. There were the heavily-laden return journeys to Spain. The relentless heat meant that the traders preferred to live in Panama City itself. Nevertheless, Portobelo was the prescribed route, the port of entry into the New World, and became as frequented as Havana or Cartagena. Today it is peopled with blacks and mulattoes, no longer brought as slaves by the colonialists. Sandra Eleta observes their daily movements, free and light as air: the young man seized by his catch of octopi; the white-haired ancient like a dethroned king, with millenarian hands that performed forced labour, hands that wanted to fire a weapon, strangle the master, hands that resisted slavery and became entwined, directed by the black Christ to accept that justice is not of this world and that we have to await kingdom come. Sandra Eleta shares her isolation and her comprehension, not only with that particular shore but moves on to other beaches, other borderlines but the hottest sands, the sands where she puts down roots, are those of Portobelo.

Paz Errázuriz knows exactly how to trap life in all its crudeness and cruelty; she knows what it is to be diabolical. In *Tango*, the woman's possessive claw with its long red nails is an ill omen. What will happen when she embeds those nails in her partner's back? What would be her catcall of jealousy? Of all the photographers, Paz Errázuriz most assumes the existence of cruelty. 'Look at us, this is how we are,' she says, 'and this is how we will be.' Her courage is admirable.

I already knew the work entitled *La Manzana de Adán* (Adam's Apple), by this photographer, with the remarkable testimonies recorded by her fellow-Chilean Claudia Donoso. Together these two women take us by the hand to the brothel known as 'La Jaula' (the Cage) in Talca, introducing us into a world peopled with transvestites. Pilar speaks of others like himself, Paty and Carolina, and of how they started out. 'I was jealous of the transvestites because they could shine like queers and my old woman wouldn't accept my cross-dressing: "Your job is to do the dishes and take care of me. Don't you get mixed up with all those artists." So I secretly went to the dance hall, danced

and attended to the clients there, until one day I dyed my hair blond and decked myself out in a see-through top. Then she was obliged to take me as I was. Washing dishes and watching, I learnt to assume different personalities, learnt how to be diabolical. Before then I was never so guileful.'

Of all the Central American countries, Guatemala is the most wounded. Wounded because there there was no Augusto Sandino and the Sandinista Revolution had no reverberations there. Guatemalans have not witnessed the recent peace accords of El Salvador and the poorest and most persecuted members of its population are massed at the frontiers in muddily neglected camps, desperate to become part of Mexico. In Guatemala the wisest and best-organized Maya kingdoms left their greatest legacy among the deep woods and high valleys of Tikal and the Petén. More than ever they are astounding cities. Any of the gods could well ask the Guatemalans: 'What have you made of my inheritance, my astronomy, my mathematics, the whorled snail of time, the temples? What have you done, you people of the Quiché and Cakchiquel, you who fought against the conquistadores?'

In Guatemala, Christ's cross has scored trails of blood and the veins of dark hands have been opened by repeated crucifixions. They fertilized the flaming colours of the dazzling forests. Suddenly, in the midst of all that greenery blazes an intense flower, a purer, more lucid blue than the sea. The weavings the men wear across their shoulders, the women over their breasts, hint at the smiles and joys they lack in their lives. Yellows and reds glint in the sun, while the pulse of drums and marimba advances like the music of the spheres.

María Cristina Orive unveils the Way of the Cross, the masked festivities and flower-offerings along its way. Twenty-two hectares of Latin American woods die every minute, and indians are felled like their forests, bent double like the little plants that creep along the ground. Fernando Benítez tells us that within fifty years there'll be no more indians left.

He's right. However, in her native Guatemala María Cristina Orive teaches us how to set foot along the way, to see the clouds, light candles to the god of twilight and, with her, believe in the indian wisdom that asks: 'Which are the herbs to sustain you within/ contain your breath of water within its earthen vessel?'

By contrast Sara Facio will never again see the subjects of her portraits. Many are famous men and their celebrity, accompanied by their sashes of honour, anticipated their deaths by many years and for all eternity. It isn't so attractive to take their portraits because they contain within the original negatives the imprint of their statuesque intentions. The Argentine Sara Facio knew them all: the tango-musician Astor Piazzola, the writers Jorge Luis Borges, Julio Cortázar in his youth (in a raincoat and the Paris métro), Adolfo Bioy-Casares ('Such a handsome man, we're right to fall for him!'), the still-green Carlos Fuentes and García Márquez, and the Peruvian Vargas Llosa who started women barking at him in Mexico, panting down the phone, 'throw him to me, throw him to me,' every time he appeared on the television screen, making political speeches.

As you leaf through her photographs, you cannot help exclaiming: 'Look, Octavio Paz! Look, Miguel Angel Asturias! How beautiful Miriám looks, Miriám, Cabrera Infante's wife!' Sara Facio is buried beneath so much fame, for fame isolates and freezes: fame is an icy diamond with sharpened facets. That is why it gives me such pleasure to see other images taken in Buenos Aires, like those of the children trapped in a basement she calls 'Heaven and Earth'.

Graciela Iturbide, slight of build and full of grace, wears a crusader's armour beneath her fragility. She is unassailable in several respects, not least in that her surname is that of the self-crowned Mexican Emperor Augustín de Iturbide (the only one Mexico has ever had besides the Aztec Moctezuma and Maximilian of Austria). Graciela Iturbide swiftly recognized that to photograph means to struggle against what's already disappearing, and for her that also means, everything that had already disappeared. Graciela began to photo-graph in the way that children do and in some way to return to childhood. She simply placed her curly head and her eye behind the lens... Even today she shoots rapidly, as though drawing butterflies in the air, or pruning clouds from on the ground.

She even makes the same mistakes as a child. At home one day, having fired off thirty-two shots, she opened her camera to exclaim: 'How idiotic of me, I never loaded it!' That was when I realized that Iturbide takes photographs to forget about herself, a matter in which she is well schooled. She never demands anything for herself; she has no desire to compete, to 'hit back,' and when her work is praised she simply turns into an ostrich and buries her head.

It's not that she's a reluctant photographer, it's just that she never puts herself forward. She won't let herself be seized: not by her friends, nor by her acolytes. There is no more modest photographer in Mexico. Behind the smile, there's another Graciela Iturbide, one who remains absent, a human being clothed in silence, a gaze turned inwards, a spell and a mystery.

This quality transfers itself through her images. 'Angel Woman' in the Sonora desert; the 'Potent Hands' in Juchitán, Oaxaca; latterly the *cholos*, those marginalized on the frontier, impaled on the world's longest boundary, the wire fences dividing Mexico from the United States. Iturbide, who has worked with an assignment from the National Indigenist Institute to document the indians, now documents their grandchildren: those who are no longer indigenous but neither are they North American, those who live landless in the no-man's land between two countries. Though they are no longer indigenous, they are unwilling to be peasants like their parents who came to sow and harvest the fruits of the land for North American masters. The 'illegals', the farmhands, the poor Mexicans who died swimming the river, wetbacks, 'little Mexican jumping beans.'

Graciela Iturbide shows their hybridization and their sharpness in their rites of passage. To them it's a matter of pride to have been incarcerated in the Soledad prison, *La Chole* as the Mexicans call it. The tattoos of the Virgin of Guadalupe on their arms, backs and fronts are marks of distinction. They paint murals and adopt East Los Angeles fashions, black shirts and jeans emblazoned with names of heavy metal and rock bands. They rebuild old cars – Buicks, Pontiacs, Cadillacs and Oldsmobiles, making them glitter and gleam, in preparation for the final journey, to Apocalypse. They take over one of the streets in the *barrio* and turn it into their own. Their wall graffiti spell out their identities: the 'White Tuft' gang written in a hand that differentiates the writing from any other in Tijuana. The girls adorn themselves with black lips. Only a photographer with Graciela Iturbide's sweetness and lack of a sense of danger could wander unharmed among these feared and ferocious gangs trespassing on the bourgeois side of Tijuana town.

Tina Modotti wrote in *Mexican Folkways*, December 1929: 'I consider myself to be a photographer and nothing else, and if my photographs differ from those generally produced in other places, that's simply because I'm not striving for "art" but for honourable photographs, without trickery, while the majority of photographers are still searching for "artistic effect" in imitation of other graphic art-forms. From this a hybrid product results, which cannot impart to their work the most significant trait it can possess: photographic quality.'

These five photographers — Sandra Eleta, Paz Errázuriz, María Cristina Orive, Sara Facio and Graciela Iturbide bear witness to Tina Modotti's saying in their work: without trickery. They are outstanding photographers because they put photographic quality first.

As once John Berger, so now our five photographers show us new ways of seeing. John Berger tells us that painting is silent, tranquil, and that there is no such thing as information. Photographs by these five women inform us. They document our great continent which still today — unlike Europe — possesses as yet undiscovered areas. Their photographs not only inform us, but also scream at us, and are a smack in the eye for anyone who sees them. The viewer is set to work thinking how, where and when these photographs were taken, under what conditions, with what equipment, if the photographers brought along DDT and mosquito-repellent on their trips, wore the boots and fatigues of an explorer, took knives or machetes to hack a way through the undergrowth, armed with a gun or a pistol or whatever. Under what kind of tent did they sleep? Every photograph contains not only the charm of the instant in which the camera clicked but also the innumerable hardships of the photographer's journey. Not only the tension within the image but also the questions about how they

came to be there, how many mountains they'd scaled along the way.

A while back women were not in the habit of running around the world being artists. Now, almost compulsively, they keep moving, lugging their own tripods, cameras and lenses, travelling in jeeps, risking their lives. Sandra and Paz and Maria Crístina and Sara and Graciela have a gift that's not just for photography but for life, a life not led like that of ordinary mortals. Their lives trap time in a box and, in order to achieve this, they wander along the earth's byways, winning time from time, getting ahead, getting there first.

Photography has reached an historic moment: it is now entering museums — ironically given that what has always received most attention is the immediacy of its witness. A photograph today has textures, shadows; it could be a Vermeer in the way it attains the mysteries of great painting. To a large extent in Latin America it has been women such as Tina Modotti and Lola Alvarez Bravo who first rested their gaze on the people in the streets and attempted to disentangle the mysteries of our continent. Nowadays many women photographers open such temple doors, combing through their countries' memories, spreading them out in the sun to dry. They know, most of all, that the world is theirs because they cradle it to their breasts. It is thanks to them that mankind has not come to an end. They know they are the creators who live forever in those who follow.

Mexico, June 1992

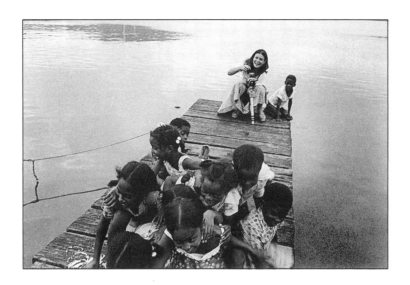

Sandra Eleta
(PANAMA)

Portobelo is a fishing port on the Caribbean coast of Panama,
centre of a free republic founded by runaway slaves in the
eighteenth century, fortified against attack not only from their
former masters but from marauding pirates, particularly the British.
Here their descendants still live and fuse the West African
traditions with those of the Americas.

photo: Paolo Gasparini

I studied photography at home in Panama, under Carlos Montafur, who had primarily taught me technique. But we don't have a proper system of instruction there: people either learn on their feet or through apprenticing themselves to studios. The style of photography — if you can call it that — is still very picturesque, old-fashioned. I took up photography as part of a History of Art degree, and learnt with a Pentax, though now I work with more or less any camera. It was only when I went to New York that I decided to take it up professionally.

It was always people that I wanted to photograph. As I've always been very shy, that was a real problem. It cost me a lot to overcome, and it was part of the self-discipline I had to acquire, to enter into a 'connection' or a relationship with the subject. The first assignment we were set when I went on the course at the International Center of Photography in New York was to follow an individual for a week and tell their story.

I chose a strange being called Moondog, a prophet with a long beard and a Viking hat! He led the life of a troubadour, wandering through the city. He had his followers, who admired his poetry. His was the first portrait I took of a human being: I was terrified, panic-stricken, of interrupting, of intruding on his personal world. It was my diffidence and I had to overcome it. I raised the camera and found his blue eyes staring straight into it, and lowered it again, thinking he would find my look offensive. But his gaze remained fixed on me and only then did I realize that he was blind.

I hadn't asked his permission first, but as soon as I'd taken the photograph I took his hand so he could touch the camera and explained that I wanted to photograph him with this camera, which was like an extension of my sight. And so we became friends, and I accompanied him for a week. It was then I learnt that a camera is an extension of your *self*, of your consciousness, that there's no

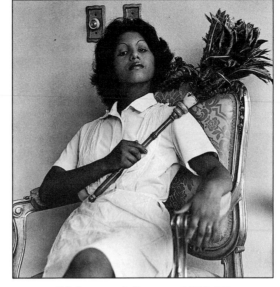

Edith, a maid, Panama, 1978–79

distinction between you and your images.

A photograph is a combination of both subject and object: at the instant of taking a photograph, the two become fused. It no longer matters which of you is the subject or the object, the difference dissolves into a single image. That's why I care little about the make of a camera, but treat each one I possess as a friend. When I took the *Portobelo* series I called that camera 'Alla', and the children there also called it 'Alla'. Each camera has a woman's name.

When I took up photography, I abandoned painting. My style was entirely non-classical and impressionistic. When I returned to Panama after four years in New York — around 1973–74 — I decided to move out of the capital and spend some time in Portobelo, on the Caribbean Coast. One of the people living there had saved my grandfather during a boating accident at sea. My father always took me to his home, introducing him as 'the man who saved your grandfather's life'. When the old man died he left my father his house which, since he hardly used it, then passed on to me. It's a tiny place, without electricity, without anything. But I took this spontaneous decision that I really wanted to stay on there.

It was the strangest feeling, as though I was fated for that house. It seemed absolutely natural to be moving in there, as though it was what I'd always waited for and wanted to do. Since the old man had actually died inside the house, the local people were afraid of it. All the more so, then, when a white woman came to live there, taking photographs and playing weird music! They began calling me *la loca* (the madwoman). I had to use the children as a bridge, because only they were intrigued rather than afraid, but then they saw I lit candles at night and they began to call me 'the witch'. There was a lot of superstition to overcome, about a single woman living there in that dead man's house. But by the time a dozen or so children had decided I was all right and more or less settled into visiting me there, then their

mothers came along to check me out and our defences began to drop.

It was as a consequence of this 'unfolding' that I came to take up my camera, rather than the other way around. I never went in there with my camera to make an anthropological study of them. My subject was people, and they were some of the people I photographed. Precisely because they were marginalized by the state, I felt a sense of identity with them. When I take a photograph, it's a matter of looking for the human being. If that human being happens to be a hunter or a fisherman, then that's an additional dimension. The primary current is that of a common humanity.

All the people there are *congos*, descendents of freed slaves, maybe three or four thousand in all. There are other communities of *congos* in the Caribbean, for example in Cuba, but Portobelo is the only one on the Latin American mainland. The *congos* have been there almost since the Conquest in the sixteenth century. The way of life they now have reflects their needs for cultural, religious, even astrological self-expression. Those who've survived have had to protect their autonomy from the psychological repression of cultural brainwashing. Their carnivals, rites and celebrations are the evidence. They mock the cultural disinheritance the Spaniards sought to impose, by reversing out their symbols of authority, wearing crowns and the like. They then give themselves titles like 'Congo of the Mosquito' or 'The Sugar-cane fly'.

They really don't have an organized religion of their own. Much derives from *santería* but they're quite secretive about it and certainly won't point out to you, say, who the priest or healer is in the community. For example, Josefa is the midwife, healer, the one who can take away the Evil Eye ... but she doesn't discuss it with you. I built up an album in the form of a personal diary; if it happens to be of anthropological interest too, that's merely circumstantial rather than intentional.

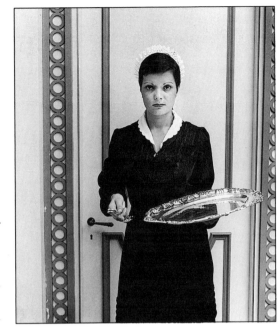

María, a servant, Spain, 1978–79

Up until now, Portobelo has been the most intimate record I've kept and the most important piece of work I've done. It also led into a completely different form of working, for not all my work has been photographic. Out of living and photographing there, there grew a women's co-operative making clothes and carpets, with whom I spent a number of years working. I helped them with the export orders for Panama and the United States, but really we all helped each other. Of course, my parents would prefer to see me settled, which for them means comfortably married, with a family. For us there still isn't a tradition of the independent woman photographer, travelling and learning about other worlds. I think it came hard at first, but now they've learnt to accept me as I am. But you must remember that even the 'artistic community' in Panama is a tiny one; that although my father is member of it — a musician — my family is a very conservative one; my way of life is hardly usual in a Latin American context.

The external constraints, however, are insignificant beside the pressures we put ourselves under. The search for an 'inner vision' means constantly raising questions about what I have to offer; what I can bring to this particular photograph. The hardest part is to keep believing in a 'personal mission', to believe in what I may be able to achieve and then achieving it. You have to be prepared to re-encounter yourself with every picture, and to be honest with yourself.

And you *know* when you've taken a strong image. You can shoot twenty and know immediately which is 'it'. You won't know until that moment, then it suddenly falls into place. When it works it's through a special kind of encounter between you and the subject photographed, whether it's a question of human response or simply of an interaction of the light. When a conjuncture like that arises, it's up to the photographer to control all the various elements so they translate

into a successful image. I try always to ask permission, gain the cooperation of the subject. It's like a third energy working together with the other elements.

Each new photograph I take, it feels like the first time; the same butterflies in the stomach, the same vertigo. Today I never feel that I know any more than yesterday. The same anxiety every time and the same surprise every time it turns out well. I'm always looking for the sense of accomplishment, and of making an accomplice. I'd be useless at photojournalism as I'm incapable of going hunting instead of connecting.

The nearest to this I came was in reportage for photography magazines such as *Camera* or *Zoom*. The assignment I perhaps enjoyed the most was on the Nicaraguan poet and priest Ernesto Cardenal, to accompany an exhibition of the Solentiname paintings for a New York Art Gallery. I returned two or three times to Solentiname and he came to visit me at Portobelo. We got on very well, although he has a very particular way of being. He dislikes conversation so we communicated more through a kind of affinity. And his form of 'poetic communication' is very much on the wavelength of the *congos*. We all understood each other perfectly.

I think influences come from all around you. Certainly, Eugene Smith was my hero when I first started out. I'm sure that's why I began taking pictures of our midwife, Josefa, inspired by his famous series. Yet something evidently wasn't working, right from the start! So that's when I had to tell myself that I should leave Eugene Smith to Eugene Smith and I deliberately set off on my own tack, making the shift from 35mm to a large-format camera. The development of my own language, my own vision came partly through trading my Pentax for a Hasselblatt!

Within Latin America, my major influence has to be Manuel Alvarez Bravo — the inspiration for a whole generation of Latin

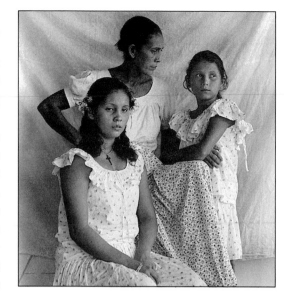

Blasina, a farmer, and her two daughters, Luzmilla and Fulvia, c. 1980

American photographers as well as Europeans like Cartier-Bresson and André Breton. This was not only for his work, but also for the help he gave when I went to Mexico for the First Photography Congress and he invited me round to his home. I spent a few days learning from him — as much from going to chapel and meditating together as from what he taught me in his laboratory. Someone of enormous significance to me. Panama, unlike Mexico, is a country almost devoid of photographic influences. The Smithsonian Institute there offers a degree of support, but mainly to photographers taking landscapes . . .

In my turn, I also get asked to teach, particularly to run workshops. It's not something I'm especially given to since the most crucial lesson is to give someone the incentive to discover their inner worth, to believe in their personal vision, to be able to look into themselves then out through the camera to express themselves. And for that there are no recipes, no prescriptions. It's simply a matter of helping someone onto the road where they discover that who they are and what they do can be part of a whole. At the Photography Festival in Arles in 1991 three women of different generations came to one of my workshops, one in her fifties, one in her thirties and one in her teens. What they had in common was the determination to open inner doors and discover what they had to offer. It ended up less as a photography than as a personal discovery workshop!

I really believe that living is about evolving. At the same time, the different indigenous Panamanian traditions interest me enormously. I want next to do a project on the children of the different peoples, linking the idea of growth with conservation. It would be an extension of the work I've already done in producing the video for Expo '92, about an encounter between a Panamanian tourist and a Kuna child. But the photographs won't be sponsored by a government ministry, so I would feel freer to treat the theme as I wish.

On the whole, I've had better experiences of working with women than men, though everything depends on individual sensitivities. Women tend to be less arrogant, make fewer assumptions. They have a greater inner freedom, a greater ability to give of themselves. On a professional level, they're far less hung up on competition. Men are always afraid of a challenge, so dominated by their own egos. The sisterhood exists!

Yet we always doubt what we do. Every time is like the first, not knowing beforehand how it will turn out. Though I probably don't want to feel totally secure: that's part of the magic and adventure of photography, making it vulnerable to whatever occurs.

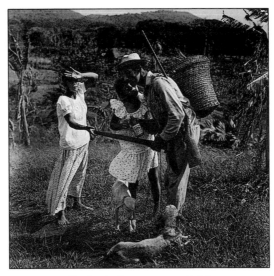

Father's departure, c. 1980

I'm always trying to keep a human mania to manipulate at bay, keep the ego out of the picture if you like. I want to erase all that, so that the work creates its own natural energy. For that you need to be able to live with insecurity — and the freshness of each encounter that accompanies it.

I always prefer 'to take as long as it takes', putting myself under pressure to keep going into things more deeply. I always stick with what I'm doing until I'm satisfied. I never leave things for tomorrow. Tomorrow doesn't exist. At the end of the day, technique is an instrument. For me its true significance lies not in its own perfection but as an instrument of love, connection and recollection.

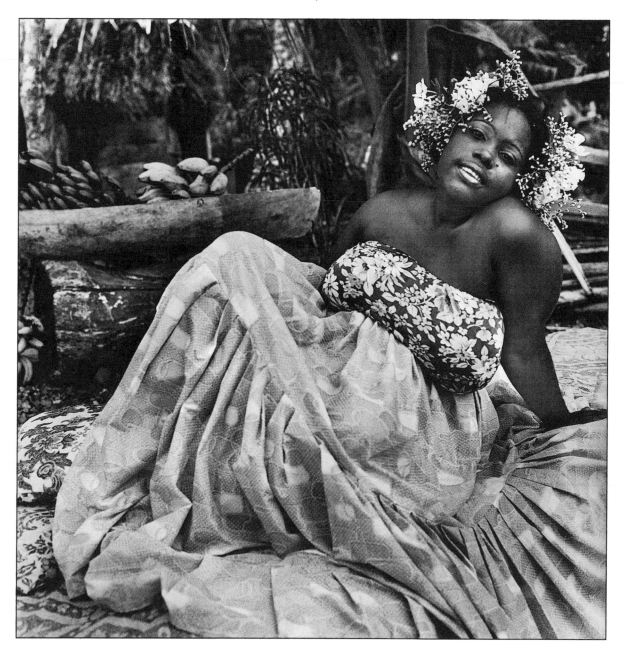

Marisella

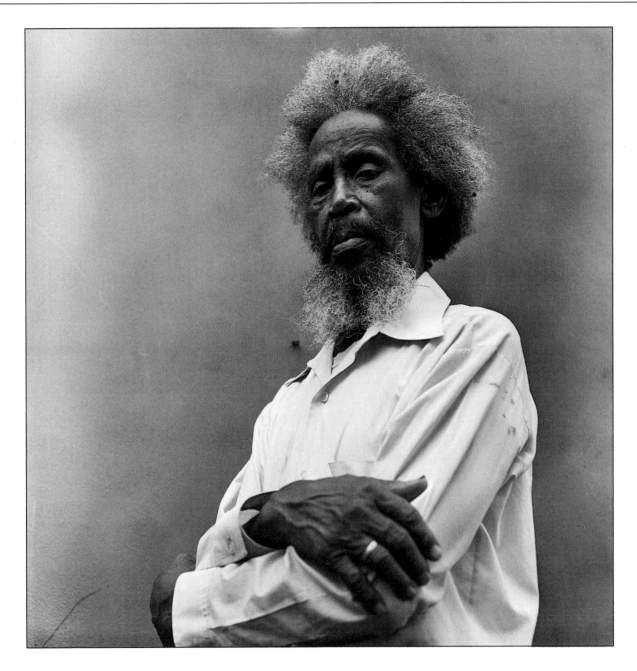

Efrain, magician and soothsayer

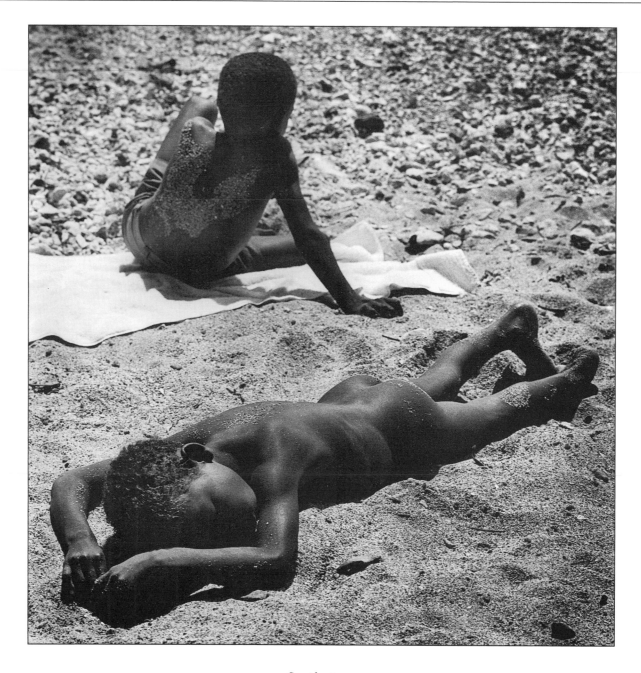

Seaside siesta

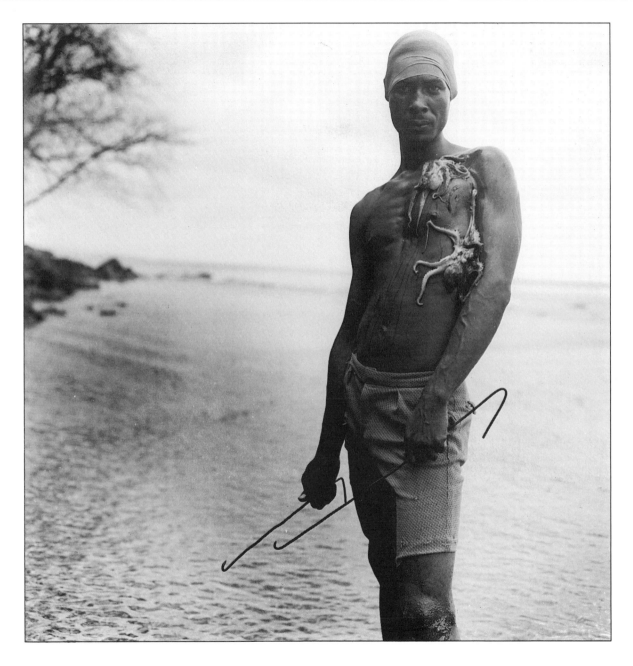

Putulungo, the Octopus Man

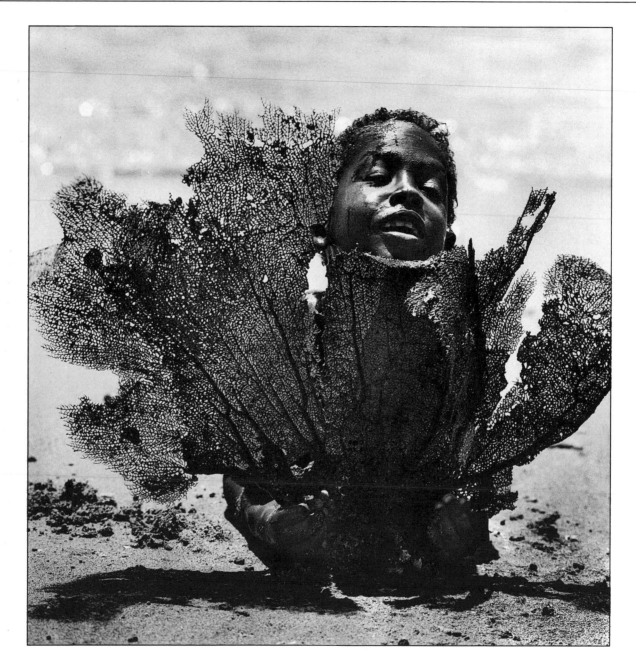

Nixon

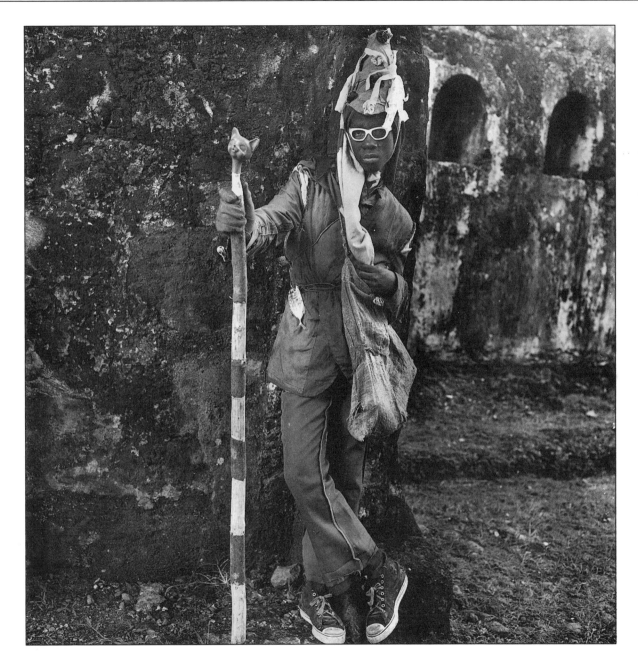

Blue Cat Congo

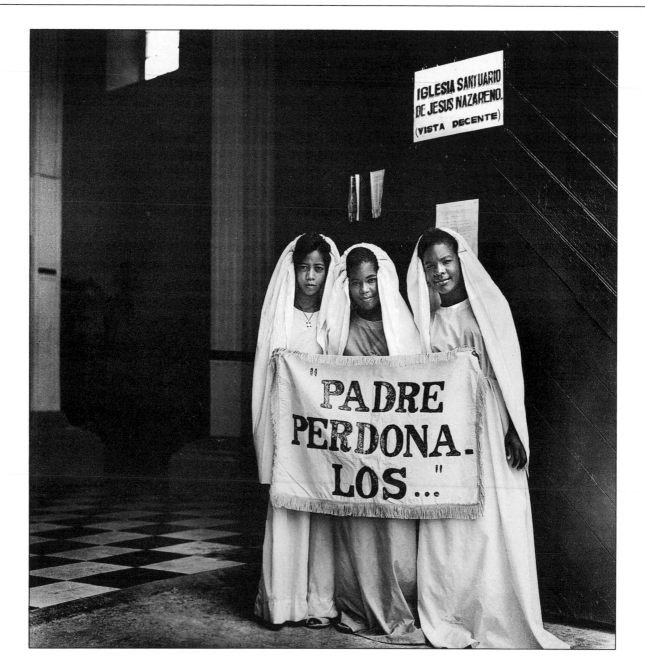

Holy Week in Portobelo

Paz Errázuriz
(CHILE)

'The marginalized' is how the photographer describes her subjects.
Within the margins of Chilean society they inhabit, they celebrate
their own family cultures, as gypsies or circus people, and create
their own structures, in the fairground, the boxing ring, the Social
Security homes for the elderly.

photo: Thomas Daskam

My training was as a primary school-teacher: I read Education at university, then taught in a number of private schools until 1972. In photography, I'm entirely self-taught, but I did start by taking portraits of children which helped make it more of a natural progression. It was quite a formal setting to start out in: very 'straight' portraits which the parents and teachers would like — nothing of the Diane Arbus look that has since been ascribed to me!

Nonetheless, I always worked in my own way. Photographically speaking, more about looking from an angle, aslant if you like, rather than face to face, confrontationally. At the same time I began working on nursery books, the first of which was a day in the life of a hen we kept here at home, 'Amalia'. This was also a private protest at the formalities of the Chilean educational

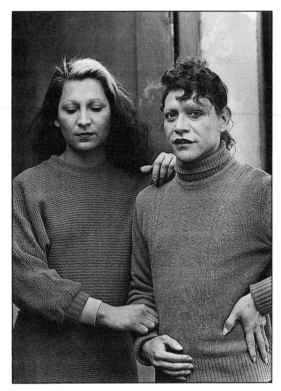

Priscila and Leyla, transvestites, 1988

system, and also had to do with introducing something experimental that I'd encountered when I was living in England in the 1960s. I originally wanted the story to unfold through images but Isabel Allende, then series editor for the publishing house, insisted: 'No, you should do the text as well. Just tell it as you see it.' So I did, quite simply.

It appeared in 1973, just before the coup which toppled Allende and incidentally put paid to the series. The coup traumatized people so much that for a time it was difficult to work, in every sense. The political situation was enormously confused and complicated; we were alarmed and afraid, and with reason; the whole situation was evil and alienating, and I felt it the more sharply since my children were still so young.

I never considered leaving, although many artists, writers and intellectuals felt compelled to. It had cost me a great deal to return to Chile once before, after living abroad for six years. It took great

personal effort to reintegrate then, and to rebuild my world anew. I'd invested so much effort and energy into that, that even when there was an opportunity for me to go to Cuba, I decided against it.

I've nothing against the outside world, and of course take photographs out of doors. But my real work goes on inside my home, inside my head — that's where we keep our ideas, isn't it? And the themes I choose also have to do with enclosed worlds, worlds outside time . . .

Going to England was a break with everything: my fascination with photography as well as my studies. I lived entirely for my then husband, Cristián, who was an impecunious student at Cambridge. I cleaned floors and houses, minded children, washed plates. My first objective was to leave home, leave my country, cut off completely. And the second was to assist Cristián, play the female victim. No, I take that back — I wasn't at all a victim. At the time I had a strange kind of attitude, was content to slave in order for Cristián to realize his own literary projects.

When I returned to Chile I discovered that the father of a friend of mine, a doctor, was a keen amateur photographer. He had a darkroom and I went along to watch him process his films. Through him I met a woman artist who also took society photographs, often to announce engagements, for a local daily newspaper. I got to retouch those of the *quinceañeras* — girls who celebrate turning fifteen with a 'coming of age', dressed like bridesmaids, with a party and a church service. It was my job to give the lowbrows a high forehead! This woman had a darkroom, but no timer, so you had to count the seconds, 'twenty-two, twenty-one'; and the image would gradually form on the paper. It was magical, almost mystical, like going back into prehistory. It became an obsession with me and I had to construct a darkroom of my own.

However, wherever I looked there was no one who gave you any kind of a chance. On the contrary I had a really bad experience with almost the only established photographer who saw some of my work, which put him in such a rage he announced, 'A housewife can never become a photographer!' That was the sum total of support I obtained from outside. And, inevitably, my encounter with myself and what I wanted to do — my vocation, if you like — pushed the separation with Cristián. Few men, least of all Chilean men, can put up with wives who move towards independence.

I have worked with other photographers, though. Under the Pinochet dictatorship, it was essential for our survival to work together. We had to obtain permission to work anywhere outside our own home; so as not to feel so threatened and exposed, we formed the Independent Photographers' Association, mostly of photojournalists. And at that time, I freelanced for a number of magazines, particularly *APSI*, though possibly at less risk than a number of my colleagues. I didn't have to keep going out on daily assignments, and had begun the project on women prostitutes, with whom I lived for a number of months, and the male prostitutes whose lives I shared through the brothers Eve and Pilar.

The strange thing is that the women more than the men didn't want me to show my portraits. Not because they feared reprisals from their families so much, more from the police. They perceived their work as something very painful, harmful to the family unit: many have daytime jobs, including ordinary clerical work or nursing. They sold themselves because they were desperate for money, and many were left with children they can't support. Whereas for the transvestite men, it's their whole life and lifestyle, and often they

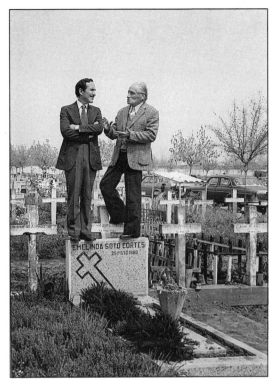

In the cemetery, anniversary of the death of Pablo Neruda, 1987

remain very close to their mothers who continue to respect and care for them, without putting them down.

Naturally I was frightened to undertake this type of work, particularly during the repression of Pinochet and his police. At one point they rounded up all the Santiago transvestites and put them on a ship offshore 'to rot', as they said, though in fact there they were subjected to torture and abuse. That broke up the community here, with many leaving and going south to Talco. The work had to be done in a semiclandestine way with Claudia [Donoso, the writer] and I working intermittently at it for five years, between 1983–88. We decided to call it *La Manzana de Adán* (Adam's Apple) because the men usually conceal their throat with a velvet ribbon or a scarf, to look more feminine.

Beside prostitution, the other established way out of the shanty-town is to assume a uniform, whether of the police or the military, in some sense to come out fighting. That's why I went on to do the series on the boxers, another violent profession that effectively excludes women. In many ways, for a woman photographer it's safer to enter an all-male world. I could take pictures of transvestites without them thinking about seducing me, or dressing up in order to make a conquest of me. With a male photographer, the pictures are bound to come out differently. To the boxers, professionally speaking, I was a species apart: no woman had entered the ring, the Chilean Boxing Association doesn't admit them. And the manager didn't want me around either and kept warning — or perhaps threatening — me with things like: 'You don't understand how violent this is, these people are outside society, you might be attacked or robbed.'

The truth is that it was the brutality of boxing that fascinated me.

It was something I couldn't understand, so I wanted to get to know the faces of those boxers, to see into their eyes. Now, yes, I think I understand a little better how far need — poverty — can really push you. Into brutality. Economic necessity that gets you into something then excludes you from the rewards. Here in Chile no one gets rich boxing but many get damaged or killed. If you win, you win peanuts and for that you can end up brain-dead. The future

Demonstration during International Women's Day, 1988

champion Martín Vargas was a national hero in 1985. But now he reels about, permanently punch-drunk, and his wife and children are destitute. There's no way in which boxing allows the poor a real way out of poverty: that's pure fantasy.

And of course it's fantasies that intrigue photographers too. There's the contrast between the real violence of these people's lives, and how they see themselves. They imagine that through all this brutality they will dig themselves out of the hole they're in. Something similar happens in the project I've been working on more recently, with the elderly who also have their ideals, their illusions. Or with the psychiatric hospital patients, literally walled in, but who retain their own world inside themselves.

In short: everyone — even photographers! — brings their own personal history to their work. Creating something is a process of discovery and of self-discovery. That doesn't surprise me: what does is that I still feel at such a childlike stage in the process. It's like completing a jigsaw, with every photo a piece of the puzzle. With the project I've now undertaken on Chilean women, I feel as though I'm adding more pieces and finally getting the picture.

Even under Pinochet my work didn't change its trajectory: I simply don't believe you can run your work on any number of parallel lines. The experience of dictatorship was a very powerful one, and a very

painful one. Work becomes a kind of escape, a way of going through that pain. I doubt that I personally would have been able to take rural landscapes full of lambs and llamas, or gone abroad to avoid witnessing the outrages perpetuated against human rights . . . against humans . . . against humanity. I don't discount those who photographed smiling faces or fluffy kittens: each of us has our own way of seeing. I can only tell you how a military dictatorship and that period affected both me personally and my work.

For example, on International Women's Day, 1988, the military mounted a savage attack on a specifically non-violent women's march. I went both to participate and to take photographs. The tear gas and water cannon drove me inside, although I couldn't see where I was headed. It turned out I'd taken refuge in a building where my dentist had his surgery. He allowed me out on his balcony and from there I could survey the repression from on high. I took a number of pictures that were used in the book Susan Meiselas edited, *Chile from Within*, but they are hardly typical of my work as a whole.

Everything I did reflected different aspects of the dictatorship: even the alienation and isolation of the individuals I selected. More specifically, I began the series on psychiatric hospitals in 1981, because there was a rumour that some of the 'disappeared' were locked away there. It wasn't true, but then the work began to gain its own momentum. Also that on the circuses, and the gypsies, all people the régime targeted for repression and whose existence I wanted to acknowledge.

Some of this work seems like a permanent ongoing project, but there's a considerable difference between the work ten years ago, and now. Over time, you refine your style considerably, gain much more certainty in your eye, your hand — your darkroom. I'm sure that

women especially find it hard to gain the confidence they need, even to know when a project is properly finished. Some seem more complete than others; when the transvestites book was done, I felt content because it had been so complicated . . . difficult . . . disturbing, leaving me with a sense of vertigo. In Chile, it's really hard to get my kind of work published, since it's not what most people want to look at. It's neither pretty nor agreeable. Yet

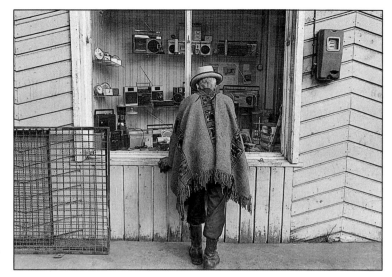

Man in Curanilahue, 1988

I prefer the idea of my pictures appearing in books rather than separately hung on walls. I'd be happy for the boxers or the circuses to appear in print.

Perhaps the public would prefer something like my series on the tango. It is danced here, though not as much as in Uruguay or Argentina, especially by older couples in working-class *barrios*. There's an issue there of passion and dedication which captivates me. It's so clear that what's happening is an encounter between lonely hearts joined by the dance. Most couples simply meet to dance and don't even see one another between tango evenings: an exclusive relationship that can last for years. My tango series was shown at a gallery called the Casa Larga, run by the woman now in charge of the Museum of Solidarity. Sadly, the Casa Larga folded. The tango show, however, was well received. It was more straightforward, it had an element of hope to it.

The last show I had was in 1991 and nothing at all to do with previous themes. It traced my son's adolescent years from fourteen to eighteen, during which I took a portrait of him every month. This was shown at the same Fine Arts Museum that threw out my work under the dictatorship and censored anything new. Now it's reopened they invited me to exhibit and I was pleased to return, not having set foot

inside for so many years. It was a great installation, all about my son: twenty-one metres of maternity.

And now I have a major retrospective being mounted in Mexico City, and a little one on the gypsies on site at La Pincoya, a poor *barrio* on the outskirts of Santiago. All this work I've printed and prepared myself, at an enormous investment of time and money. The one extended project I took in colour was doomed — the laboratory destroyed every one of my films, and I got no compensation beyond having them replaced with new rolls. It was on the *animitas*, tiny shrines built at roadsides to commemorate those who die there suddenly, often violently. Relatives continue visiting the little chapels with flowers and candles and crucifixes. I covered 5000 kilometres and a hundred films of *animitas* for a colour book. And the lab lost the lot!

At the moment I'm steering clear of official celebrations of the *500 Years*: to me there's nothing to celebrate, quite the opposite. At a popular level, the remaining indigenous peoples have demonstrated and demanded the return of their lands — and been heavily suppressed for their pains. Those who are marginalized geographically are marginalized economically: the Araucanians living mainly in the far south and smaller groups scattered in the remoter regions of Chile. I've thought of working with minority groups in general this year, as I did before in Magellanes and along the Vigo Canal. But I've focused instead on portraits of a very old woman, perhaps the last remaining pure Alagalufe. An extraordinary person and a very lonely one: it's more my way to concentrate on an individual. Back to the photographer encountering herself in every portrait of another . . .

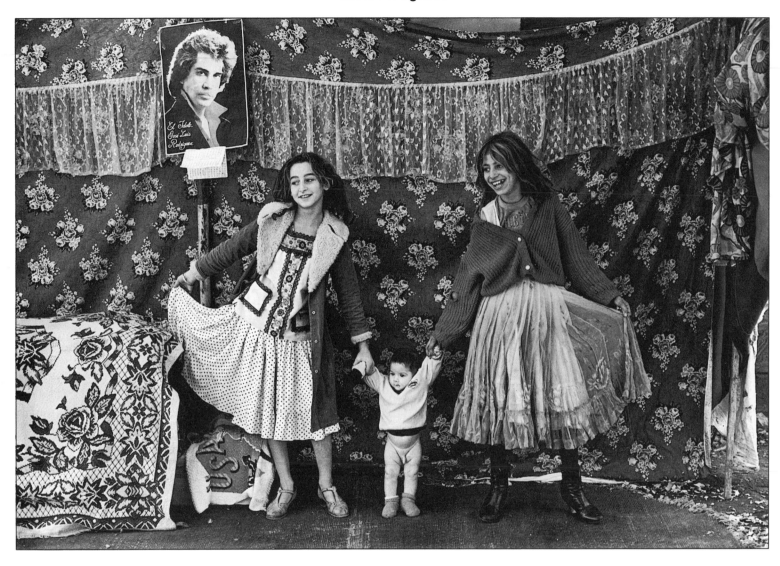

Gypsy girls, 1986

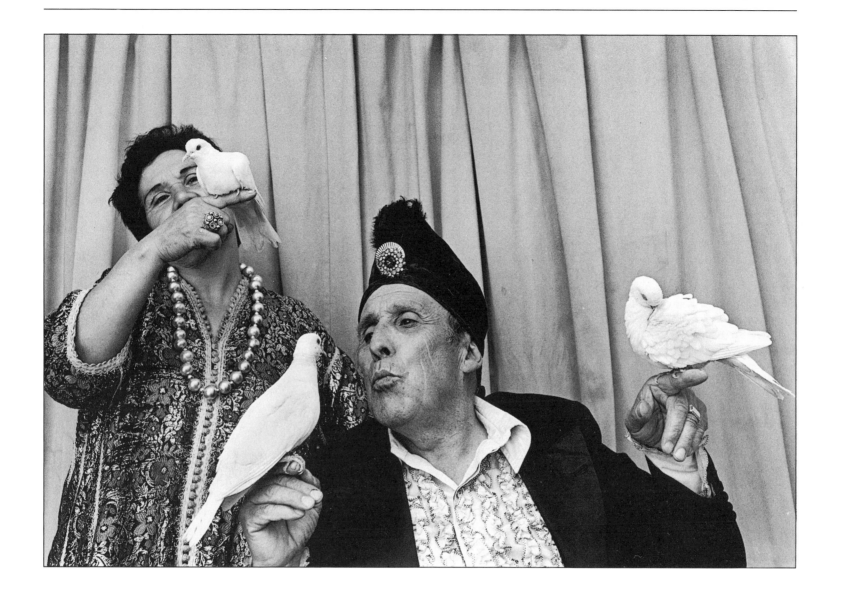

Magician and his wife, 1989

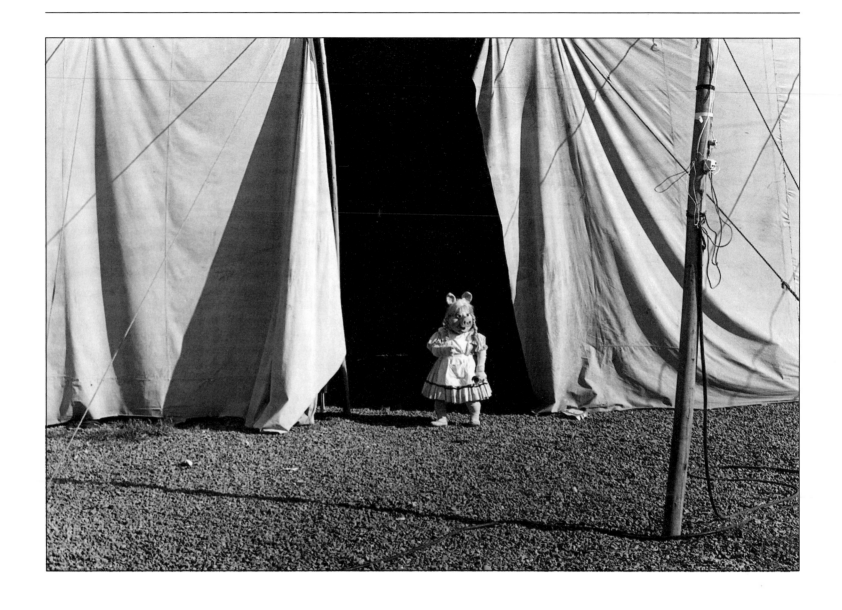

Miss Piggy, 1982

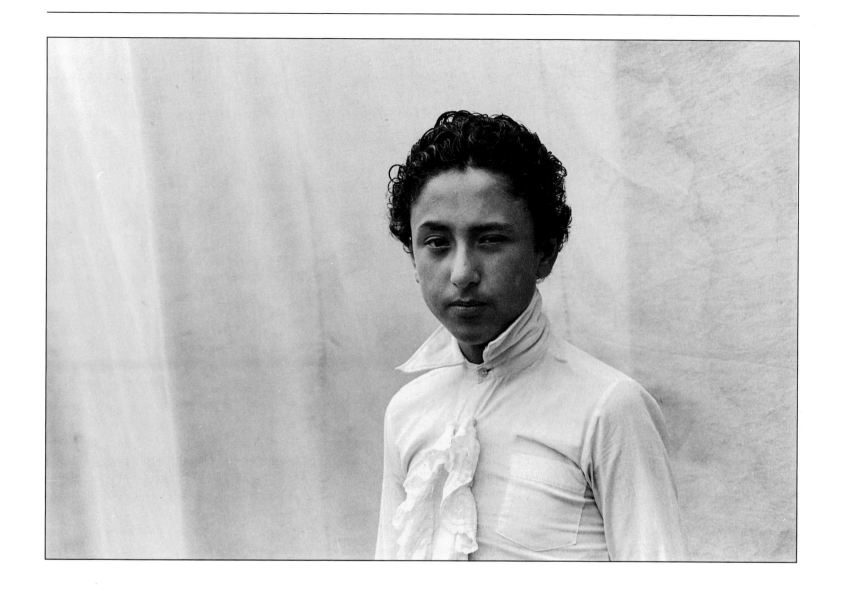

Circus boy, 1984

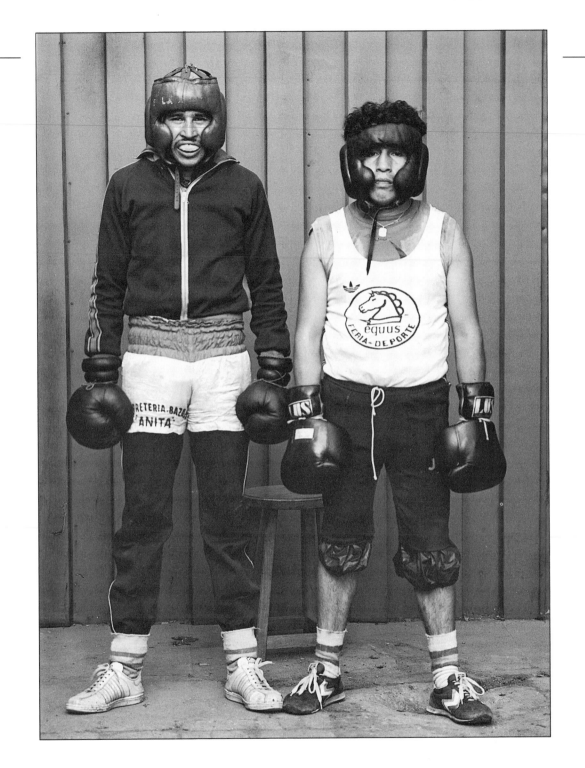

Two boxers, 1987

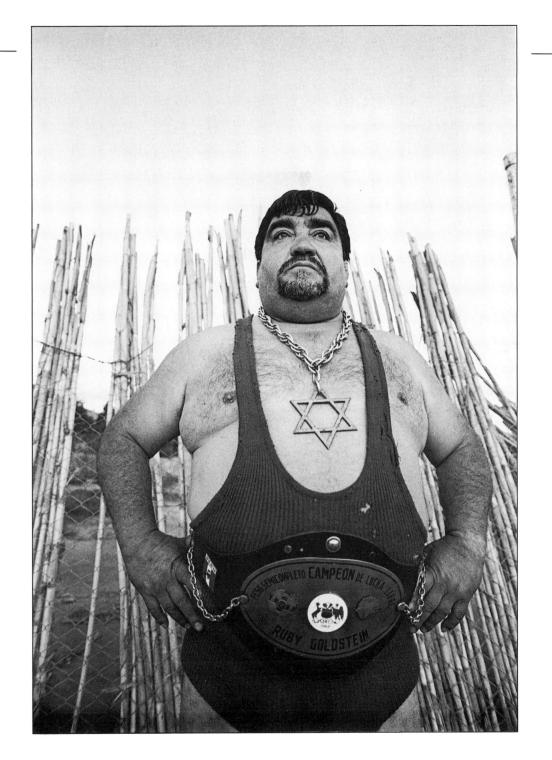

Wrestler, 1988

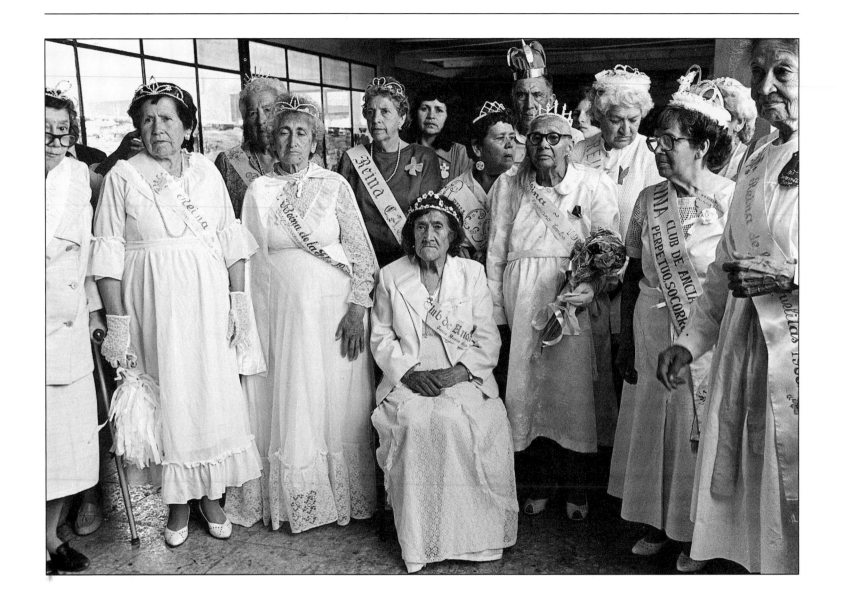

Beauty contest, old people's home, 1990

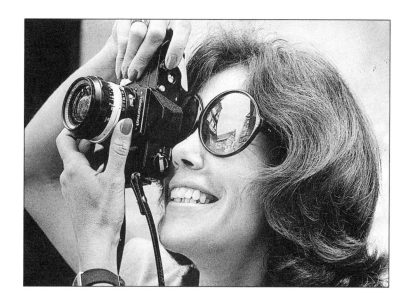

María Cristina Orive

(GUATEMALA)

Good Friday in Guatemala, where the majority population is Maya,
is a time of synchronizing precolumbian and Roman Catholic
rituals. The intricately patterned carpets of dyed sawdust, seeds and
petals; the bells, mirrors and animals play a more ancient part in
processions and ceremonies otherwise reminiscent of
Holy Week in Spain.

Nowadays, it is possible to take a course in media studies. When I was young, such courses simply didn't exist, even though communication has always been my field of interest. I was still in secondary school when I took on producing our 'Year Book'. I was interested in the idea of creating a book for its own sake, telling a story — in this instance of my class and my school.

It was illustrated with photographs, although these were taken

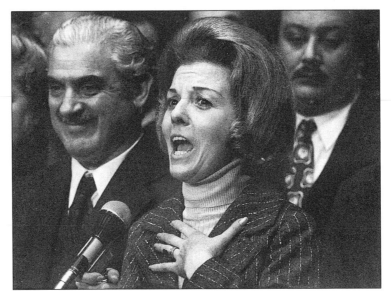

Isabel Perón, Vice-Presidential candidate, Buenos Aires, 1974

by a professional. My rôle as writer and editor was one I took with me to the United States, where I studied French at Smith College. My mother was of French origin — her grandfather, Emilio Goubaud, founded the first bookshop in Guatemala in the 1880s. A French bookshop of course! My grandfather inherited and ran it until the 1950s, when it finally closed.

So, at Smith College I chose to study French humanities, because I was raised in a literary, artistic French atmosphere. Thanks to the bookshop, my mother was more used to reading in French than Spanish — and was a great correspondent, writing lengthy letters in her own hand. She grew up with an aunt, Meches Machado, a Guatemalan Colette. She had a literary salon through which passed Jose Martí, Ruben Darío, and the rest of the literati, together with some of the most notable lawyers of the day, as her father, Antonio Machado (the poet's nephew), was president of the Chief Court of Justice. My mother's adolescence was formed by these people.

My parents were regarded as being very modern for not sending any of their five children to denominational schools. My mother always wanted us to lead our own lives and I, the youngest, decided to attend a tiny school run by an Alsatian German, who'd come out to Guatemala as tutor to a friend of mine. He was a mathematician, his

sister a painter. There were around forty-five pupils when I entered — speaking a mixture of Spanish, German, French and English — and the school was regarded as being very progressive and left its mark on us all, turning us into 'world citizens'.

While it's true to say that we each found our own voice there, I was yet to come across either photography or photographers. Other media interested me more, and at university I specialized in radio journalism. My idea was already that if people knew more about the arts they'd be happier: simple as that. Certainly, if I'm miserable I go to a film, an exhibition, a theatre, or read a 'good' book. One important reason for moving to live in Buenos Aires. Living through works of art is the greatest of resources, the greatest journey there is. To escape or get stuck only intensifies — maybe leads to — greater repression.

On leaving college, I returned to Guatemala, but without any desire for a normal sort of job. Having just followed a course on editing for radio at Boston, I proposed to the classical music station that they sell me air-time. I began with an hour from eight to nine in the evening. It was enormously successful, particularly with the choral cycles I produced at Christmas and the operas, adapted to new performers. So popular, in fact, that they had to send in records by the planeload from Miami and New Orleans! We were so culturally dependent on the United States that we relayed far more European than Latin American music — and, to us, the US is so near, with so many stereos!

At the same time I worked at a daily newspaper, in charge of the Saturday cultural supplement. Through interviewing and requesting articles from a variety of specialists, it was possible to evoke a public

consciousness of what was happening in the arts. I spent my four years there turning art into news.

In October 1957 I decided to spend a year in Paris. Jazz and existentialism were already *démodés*: it was the period of Boulez, Berg, Schönberg, Webern and twelve-tone music. I discovered Jackson Pollock and 'action painting'. I came across and fell in love with la Callas. I was European arts correspondent for *El Imparcial*, freelancing elsewhere. Then I entered the ORTF [French Radio and Television Organization] Spanish language service and divided my time between written and radio journalism, gradually concentrating exclusively on the latter.

The proof of how much I liked Paris is that I stayed there for fifteen years! That was where I started taking photographs, just for myself. Any trip I went on, I created an album to tell the story of my travels. Soon this translated into work for an Argentine magazine, *Primera Plana*, which had asked Mario Vargas Llosa for a series of articles. We had worked together at the ORTF and were already close friends: he'd seen my pictures and agreed to the series on the condition that I supplied the images.

Our first assignment together was about a little restaurant in the Latin Quarter that served as a meeting place, poste restante, even a banking agency for hippies from around Europe. It was the 1960s, and the place was very much of that time, run by a real character.

Thanks to my work for the radio, I came to know all the Latin American artists and intellectuals passing through Paris. Not to mention those I worked with at the radio station: Mario Vargas Llosa, Mario Benedetti, Jorge Enrique Adoum, Sévero Sarduy, Jorge Edwards. The lot. Paradoxically, it was Paris that deepened my knowledge of Latin America.

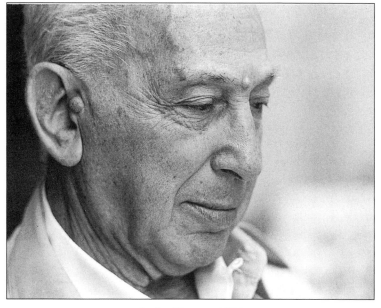

André Kertész, 1979

I worked there until 1969, when they threw me out. I'd been active in the May '68 strikes, since our section was the largest within the ORTF and the ORTF mounted one of the major strikes. At the same time, I was already working for a photo agency, specializing in the theatre.

I'd always loved the theatre and felt at home there. ASA press distributed the first story I'd done on the Argentine director Lavelli's production of Panozzi's *Concilio de Amor* then took me on properly, to cover Latin America. I took a trip back there with the redundancy money from the ORTF and included everything in my work — economic and political features as much as artistic ones.

All areas interested me, and it was a good time, just at the start of the 1970s. I didn't want to do news stories: I preferred to follow stories through. For example I did a report on coffee and its importance to the cultivator countries; then the 'Banana War', when the exporting countries attempted to create an organization similar to the OPEC to artificially fix prices. Another was on the Panama Canal, which I went down on a Russian ship. I included pictures of the construction still going on and of life on the Canal. By the time I reached the Southern Cone (Uruguay, Chile, Argentina) I had transferred to SIPA press and was prioritizing political reporting, particularly with the election of Salvador Allende in Chile.

As of 1972 I worked regularly for most of the major photo magazines: *Paris Match, Stern, Newsweek, l'Express*, and many of the Spanish ones. SIPA put my work out worldwide, including to all the Arab countries. Those were among the best, whole pages given over to single reproductions. That's every photographer's dream: the

whole sequence run just as you conceived it, ten or twelve images at a time.

I worked in both black-and-white and colour, sending off all the film unexposed. I found that a really difficult way in which to work: it's intensely frustrating not to see your own films developed. After a year, I decided to move to Buenos Aires and establish myself there. Together with Sara Facio, we founded La Azotea photographic publishers in 1973. Then I started processing my own black-and-white film, captioning and sending it off, but keeping material for my own files. The colour still had to be sent off unprocessed.

La Azotea was a joint project from the beginning. I'd known of Sara Facio since I was in Paris. I looked her up when I came to Buenos Aires and we immediately became friends. She helped me a lot. When a crew was needed to cover the elections, Perón's return or the occasion of his death, we'd work together, sometimes with another couple of photographers.

There's always an uneasy relationship between staffers and freelancers on any magazine. Often when I produced major features, they'd appear badly cut or cropped, with the text edited out or rewritten. If they publish intact, what are the staffers doing there? But after a while I became tired of this kind of media manipulation. They kept reproducing the image they had of our reality, according to whatever their ideological line was. Nothing changed even when, in 1974, I went on to GAMMA press.

I switched because I hoped they'd take my work more seriously, and they were certainly a bigger agency. When they called me, I had no hesitation in accepting. I travelled widely through Latin America, and came to know a lot of photographers. A number of them were published in La Azotea's *Photographers Collection*. This was quite a change from our first project — producing postcards of work by ten Argentine photographers. We published according to what seemed to

Miguel Angel Asturias, Guatemalan writer and Nobel Prizewinner, Canary Islands, 1974

us work that was both new and interesting: we didn't even know most of the photographers.

It took until 1982 to commit myself completely to the publishing enterprise. For me it's become the most pure, direct medium of communication between photographer and public. There's no manipulation of the text, not even the captions, just two combined sensitivities. Of course, it's afterwards that the work begins — one has to convince the printers, the distributor, the bookshops . . .

In Argentina there had long been an awareness of both national and European photography. It remained important to introduce work from Mexico, Brazil, Panama. We were — are — the only Latin American photographic publishers. Then we discovered a considerable interest in Europe. It started in 1971, with the Agathe Gaillard gallery in Paris. There was a series called *Les Chefs d'Oeuvre de la Photographie* which was then taken on by Sue Davies at London's Photographers' Gallery. Thereafter, New York requested them and it was mainly through an unofficial women's network that their distribution continued to multiply.

Women have less of a sense of competition, more of solidarity than men. It goes without saying that I'm a feminist, so of course we've foregrounded a lot of women in all our publications. Grete Stern, Annemarie Heinrich, Sandra Eleta. We've also published another postcard series called *Las Hechiceras* [the Enchantresses]. They are strong images of women who've excelled in their chosen field, regardless of whether they were feminists — or we happened to agree with their viewpoint.

Our series on oustanding women arose from the same starting point: if we don't concern ourselves with Latin America photography, talk photographically of our own realities, make known the work and faces of these women, nobody is going to do it on our behalf.

In 1979, together with Alicia D'Amico, Annemarie Heinrich, Juan Travnik and Andy Goldstein, Sara Facio and I founded the Argentine Photographic Association. Yes, women were prominent here as throughout the history of Latin America photography. Maybe that's because it's an intimate art, like writing.

But to return to our gallery. I knew André Kertész, for example, and we staged the last exhibition of his life — just six weeks before

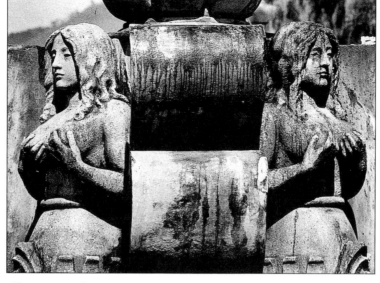

Fountain of the Sirens, Convento de las Mercedes, Guatemala, 1978

he died — in Buenos Aires, and he came for the opening. In conjunction with the Agathe Gaillard Gallery, in 1980 we also showed *Masterpieces of French Photography*. That was quite an event; the first time ordinary Argentines could see 'in real life' photographs that so far they'd only seen in magazines. Photos by Lartigue, Cartier-Bresson, Doisneau, Gisèle Freund, Claude Batho. It was incredible. They then toured the interior of the country, to Rosario, Córdoba, La Plata — across vast distances, Buenos Aires province alone being as big as all France.

We'd had the idea of a gallery for a long time, but it could only come together in 1985, with the return to democracy. I'd never considered leaving Argentina throughout the military dictatorships, but of course I was scared: fascism acts so arbitrarily . . . For me democracy is simply liberty, but it was fascism that made me aware of what it really represents. When the régime changed, the country as a whole changed: the whole legal system changed for a start. And I experienced the change, emotionally and in every way: not having to dread that your book was going to be censored, or your exhibition or your programme. Suddenly there was freedom again, in the street, the theatre, freedom of thought. Under a system of censorship there always exists a state of self-censorship, leading to so much mediocrity . . .

We opened with *Masterpieces of Argentine Portraiture*, one of the most powerful exhibitions Sara has ever curated. It contained work by four persecuted European immigrants who'd sought refuge in Argentina and who'd re-encountered fascism. They had brought their European style but had developed along new lines: Argentina has functioned like that, as a country of European immigrants, a really cosmopolitan one. And, although Sara Facio runs the Gallery, I built up a number of contacts when I lived in Europe — like Sebastião Salgado, Ralph Gibson, Kertész himself; some exhibitions came through the relevant embassies (Salomon, Juan Rulfo), and others I literally brought home under my arm. Cartier-Bresson couldn't believe his eyes when I appeared at Agathe Gaillard's with the French Masterpieces under my arm: he claimed that never had his prints been returned so swiftly and in such good condition. Altogether I'd carried back one hundred and ninety of them.

For now, my books are my principal project. I regard each one as a child, though I always like the last a bit the best. *Witcomb, Our Yesterdays* is the latest. It's about an Englishman who became the first great Argentine photographer, and who teaches us our history through that of immigration. *Portobelo* is a book full of poetry and *Acts of Faith in Guatemala* moves on each time I look at it.

People believe that a photographic book is a matter of sticking one image next to another. But it's a whole rhythm, a way of breathing, a question of evolving an idea, an emotion, through photography. But the greatest satisfaction to me is *La Azotea*, I have great faith in its cultural importance. After all, throughout my life, what has counted most has been to participate culturally and actively in the society where I live.

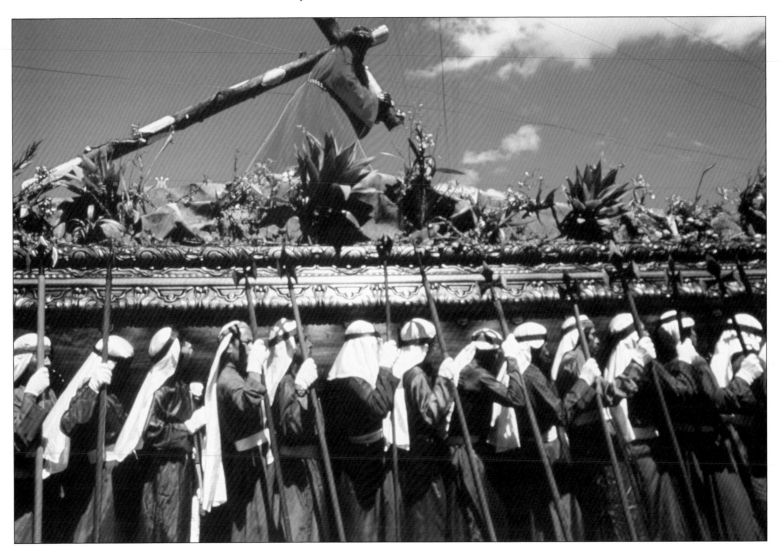

Jesus of Nazareth's holy image is taken through the city streets, Antigua, 1973

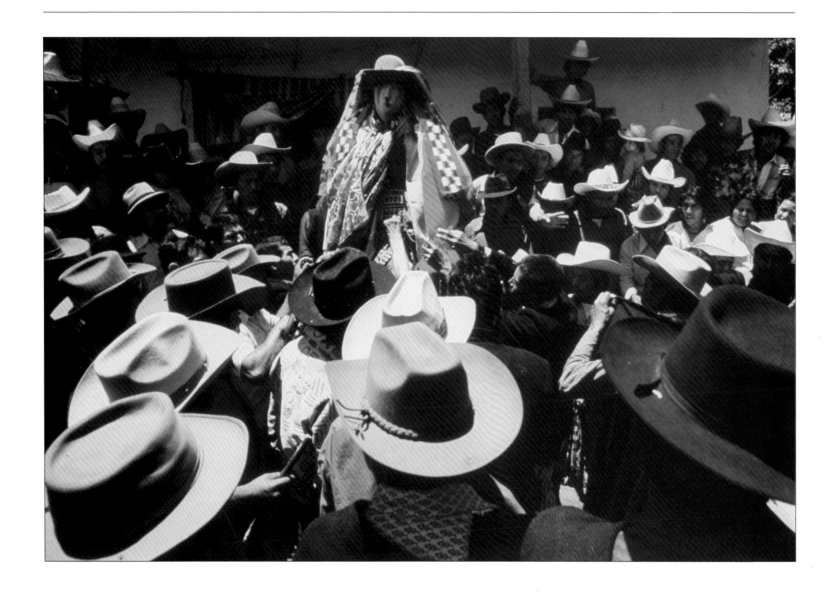

The Maximón is taken from his house, Santiago Atitlán, 1973

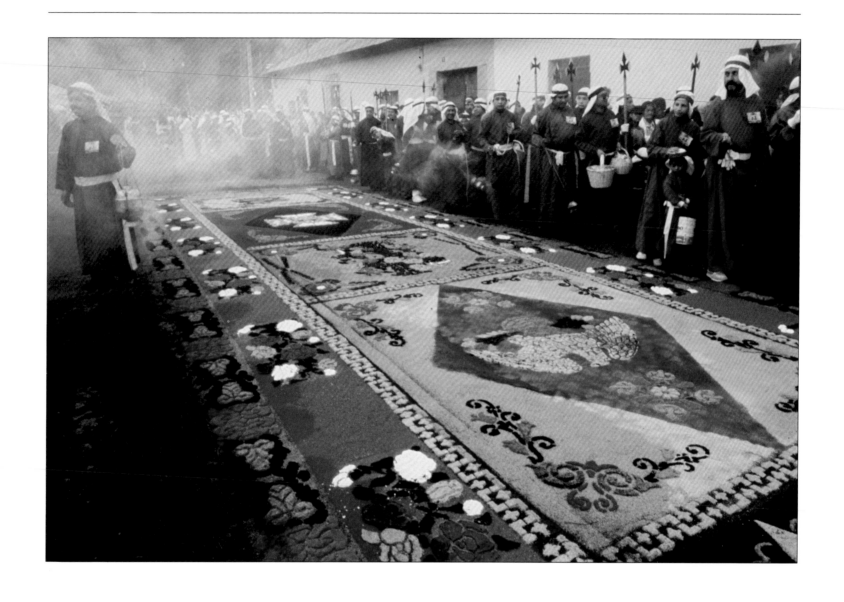

Good Friday, Antigua, Guatemala, 1973
The procession for Our Lord of Mercy over carpets patterned with dyed sawdust.
The pilgrims following the route are dressed as Nazarenes.

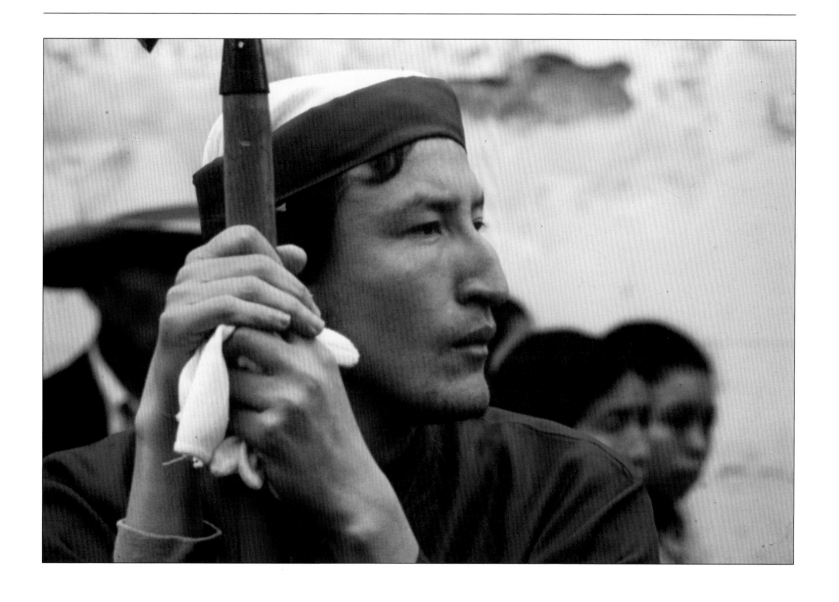

Parish of the Nazarene, Good Friday, Antigua, Guatemala, 1987

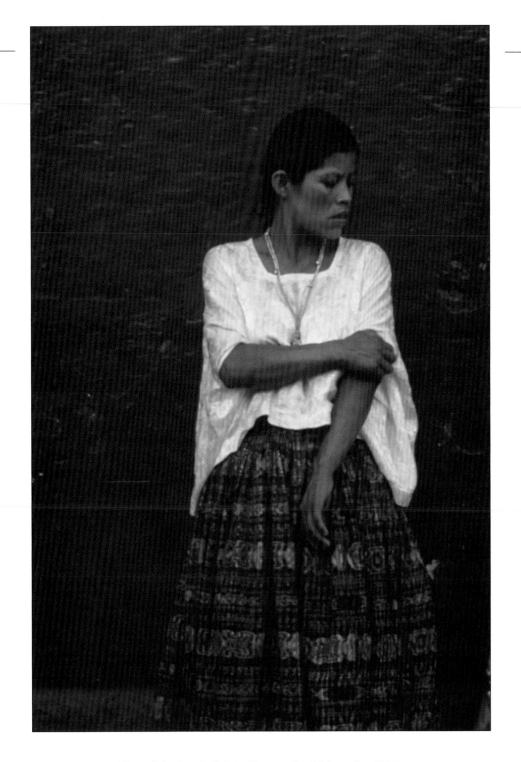

Day of the Dead, Cobán, Guatemala, 1 November 1973

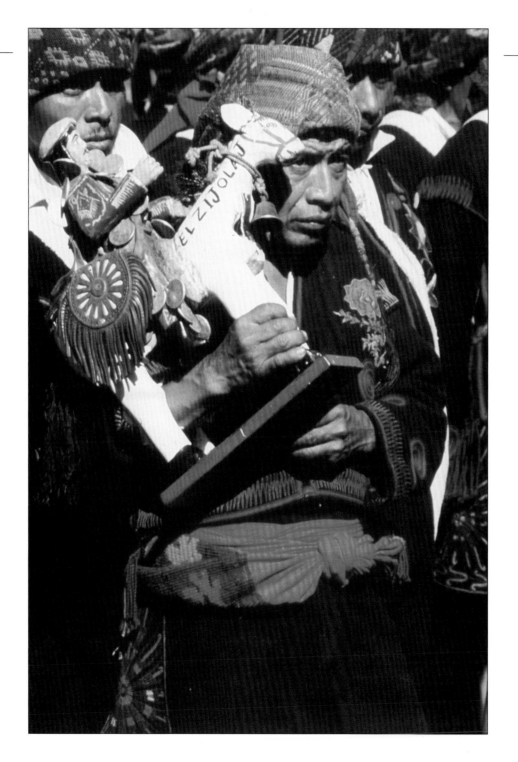

Town official in a procession for the feast of Saint Thomas, Chichicastenango, 1973

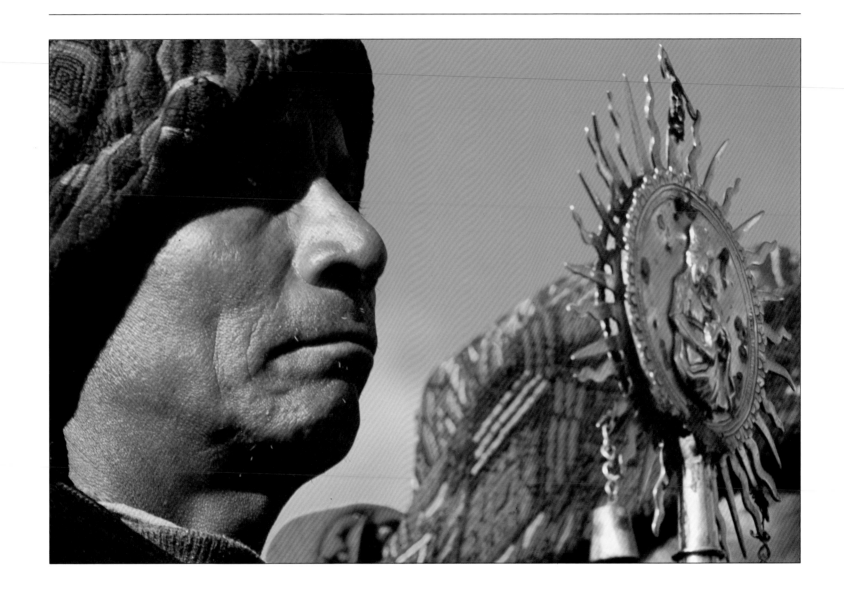

Parish fraternity of Saint Thomas on his feast day, Chichicastenango, 1973

Sara Facio

(ARGENTINA)

For forty years, Sara Facio has photographed people on the streets
of her native Buenos Aires — as well as establishing her reputation
taking studio portraits of authors. Here the two combine as writers
and readers sit at pavement cafés; here too everyone is brought on
to the street for an occasion like the grand funeral of Argentina's
populist president, General Perón.

photo: María Cristina Orive

My background is in fine arts. I qualified as a lecturer in painting and drawing in 1954, and immediately went to study art history in Paris. I first came across photography when I went to look at works in Munich's Pinacotek gallery. It happened simply because my visit coincided with the 'boom' in German cameras. I bought a 35mm Agfa and started taking pictures.

I was really only familiar with photography as nostalgia, pictures of baptisms and weddings, commercial photographs. In Germany I discovered it as a means of expression, not at all the aesthetically dead material we see here in the salons and camera clubs, but with a far stronger presence, that seemed to be more relevant and contemporary than painting. And I had to recognize I was getting bored and isolated spending the whole day painting: I preferred working outside on the streets, in

Gracia Cutuli and Claudia Segovia,
Dancers with Tango Argentina, *1980*

the midst of the real world. Photography afforded me a far greater opportunity to approach life and the social problems that so absorbed me. It was love at first sight and I left behind everything to do with art history!

However some of that cultural interest transferred to photography: its history, theory, technique. Somehow it all fitted together, as I kept on taking pictures and had the luck to get into journalism, which I enjoyed from the beginning. I studied photography under Luis D'Amico, including a period in Italy, then one with Kodak, in the United States. In Buenos Aires, the German immigrant Annemarie Heinrich taught me how to light: in 1961 I won my first photography prize and in 1963 held my first exhibition, of photos of Argentine writers.

In 1966 I was given my own page in the daily *La Nación*: it seemed a great responsibility and I extended it to confront the immense changes taking place in photography. I went to Fotokina every year in Germany and kept abreast of new technical developments, visiting all the exhibitions. You ought to know that for Argentines — most of all, for people from Buenos Aires — 'the world' simply signifies Europe. Ours is a country that has always looked outwards, across the Atlantic. Now the United States has finally succeeded in making an impact, principally through television and principally on a generation younger than mine. For me, everything to do with cultural and social values derives from Europe, particularly England, France, Spain and Italy, which is where my family originates from.

My education was primarily French: if you look at the governments we had from the 1880s through to the 1940s you'll see why. Nearly every cultural influence was French; it was the economies that were constructed on English models. This means Argentines have a perpetual identity crisis and, since my real interest at the time was in reportage, we decided to do a book on Buenos Aires in 1968, with a text by Julio Cortázar. I say 'we', meaning myself and Alicia D'Amico, with whom I shared a commercial studio. My greatest wish was to be a kind of witness, documenting my country, my city, the people I respected intellectually. I'm not over-concerned with social trends, fashions for documenting poverty and misery, the political elements. What matters most to me are those people that make a country special.

We tried to take quotes from a variety of writers for the Buenos Aires book, and then the editor directly approached Julio Cortázar, at that time on the crest of the wave that was Latin American writing of the 1960s. He wouldn't answer without seeing the pictures so we went to Paris, where he lived in exile: he liked the pictures, agreed at once,

and we became firm friends. I then described another book I had in mind, the *Humanario*, on mental patients – at a time when no one else considered it a fit topic for photography. Alicia and I had considered Beckett as a possible writer, but he was ill and unable to help. So Cortázar offered to do the text for that book as well.

We worked with other authors when we did the book *Retratos y Autoretratos* [Portraits and Self-portraits] in 1974. We shot images

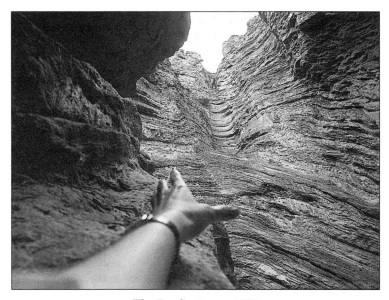

The Devil's Gorge, 1978

of the authors and asked each one for a self-descriptive caption. The only ones who refused, unfortunately, were two women — Victoria Ocampo and María Elena Walsh. Twenty-five were included and the thing was a phenomenal success: 20,000 copies, printed on newsprint with no attention to quality. It's taken twenty years to be exhibited unabridged.

The whole publishing business in Argentina is a very fraught one, usually left to 'crazies' like María Cristina Orive and me. There was another radical left-wing publishing collective called *Crisis* which had published my first book and a magazine bearing the name *Crisis*, but when the military came in they imprisoned the lot, and few of the staff survived.

Even without taking a political line, of course we were also greatly affected by the juntas. You weren't allowed to take your camera onto the streets, and many of the individuals I photographed were under suspicion. All our subjects were suspect, and most famous writers were on the left. It was a period of complete madness, in which our books were suppressed for what they showed, and because Cortázar had come out in open opposition to the government: Argentina was supposed to be a country full of happy people, no one discontent, let alone mentally affected. The coup coincided with the publication of

Humanario, a time when people closed their doors on reality and books were left to die.

Some of the most courageous opposition figures, working both as critics and in the bookshops, publicized our work. But on television, for example, nothing passed the censor. It wasn't official, you understand, but an extraordinary degree of self-censorship within the media, with blacklists operating everywhere, names that could never be named. They reviewed the book on the radio, and managed not to mention that Cortázar had written it!

But you have to continue working in whatever way you can. I'd started the postcard series in 1973, in the period of struggle between right- and left-wing Peronist factions, those on the left joining the Montoneros guerrilla movement. Nothing political appeared, not on Perón here, nor on Allende in Chile, nobody would sell them. And my page in *La Nación* was stopped. I never joined any leftist group, but I was quite open in my opposition to any form of military intervention and the horrific governments that resulted. Often, participation made no difference to the military: they disappeared thousands of people, including many of my friends, whether they were politically committed or not.

What was the point of being afraid? That way they win! No, I never considered leaving, though so many went into exile. Nor was I about to pick up a revolver. My form of struggle and opposition was through my work, even though I had to take a lot of criticism from people who'd left, for being 'a government accomplice' because I went on working! I did what I felt I had to do which was to carry on through those ten awful years: we produced our first book on contemporary Argentine photography, we held exhibitions and ran workshops

wherever anyone would let us. And we formed the first Argentine Association of Photographers, both to continue meeting and to stop photography from withering away altogether here.

We had to provide mutual support and stimulation — or else collaborate in the juntas' intention that photographers should return to the studio and churn out pictures of blossoms and song-birds. We held international shows to demonstrate

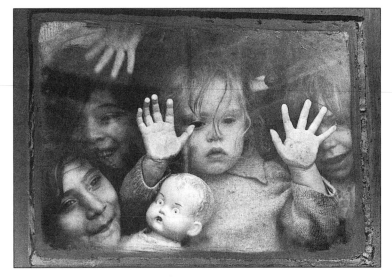

Roughly living, 1963

this I put my foot down: I know — and like — them both personally so I know perfectly well that neither has the slightest interest in photography. I nearly got killed for my pains but I still hold that only when photographers are deemed fit to judge and award literature prizes should writers do the same for photography.

Women are if you like a subgroup within the sub-group of photography. Not in terms of what we do but how we're treated.

we were still alive and active! Some photographers didn't want to exhibit in Argentina at that time, like Cartier-Bresson, who María Cristina had to go and convince personally. Paradoxically, his participation undoubtedly helped us to gain the backing of a French bank to produce the catalogue. We had to ensure that whatever we did was independent of our government for the paradox was that, little as they liked what we did, once it was public and successful, of course they wanted to hijack it for their own propagandist ends. We refused any form of discussion, funding, publicity or whatever with the military régimes. Because the members of the Association were well-known, and what we did attracted international support, they didn't dare touch us.

And so we continued meeting, often at Hector Comesaña's house, or at Annemarie Heinrich's, pooling resources to send one or more of us to international symposia in other countries, like the first Latin American photography conference, held in Mexico. And when Galtieri fell, the atmosphere changed overnight. It seemed to me that suddenly the streets were full of photographers clicking away!

Ten years ago the first Latin American photography conference was held in Mexico and to attract attention 'famous names' were nominated as judges to obtain maximum media coverage. Those first put forward were Mario Benedetti and Gabriel García Márquez. At

Here all political parties have supported a law going through the National Congress that at least a third of candidates adopted should be women. Yet when I proposed that for the open submission of our national photography competition at least a third of the organizing committee should be women — I wasn't even able to get as far as proposing the same for the judges! Shortly before the whole project was due to get under way, the Minister of Culture changed and the whole thing was scuppered.

In terms of my own work I'm a little bored feeling, particularly with the portraits, that I've done it all before. So I take out my images and look hard at them against the light, and I continue lighting them, touching them up and painting them in. I like playing with them on the computer too, or 'subjecting them to laser treatment'. But most of all I enjoy returning to my starting-point, using paints to work with black-and-white images. I've done one series that I have called the *Enchantresses*, all portraits of strong and in some way captivating women. They are women who've reached a certain maturity, when I find their faces much more interesting, perhaps because they have developed such a strong inner life. Also, paradoxically, because they're much less accustomed to posing than men, you catch something different. Another series I've recently begun is on animals — particularly wild animals — in cities. You discover them in the

most unlikely places, as gargoyles, in shoe shops . . .

On the one hand it's true that I threw myself into photography as a total vocation. Not only did I turn professional right from the start, but I've worked in just about every related discipline. In Argentina it's not enough to be just a photographer: you have to do something of everything. And so I run workshops, teach classes, write articles and even books.

There's no intellectual weight accorded to photography here, no critics seriously interested in it. The store *Harrods* has a floor devoted to a mixed media exhibition: the sculpture and paintings get reviewed, the photography ignored. That's the norm. We've no Susan Sontag as they do in the United States, no Roland Barthes as in Europe. In Mexico maybe a dozen

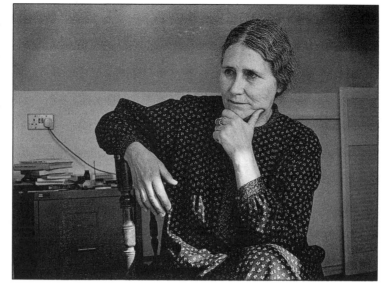

Doris Lessing, 1980

serious writers take photography seriously — Octavio Paz, Carlos Fuentes, Carlos Monsivais, Elena Poniatowska to name a few. Here only Julio Cortázar and María Elena Walsh have considered it a subject worthy of mention.

You can't expect that a country which has survived a decade of such repression and terror will instantaneously transform itself into one of great accomplishment and geniality. It has to pass through a period of introspection, of soul-searching, to arrive at a greater maturity. Only the youth, those without memory, can suddenly become part of a new liberty, a new photography. Art can't be made to order, least of all to government orders. Many of us are still searching within and into our past.

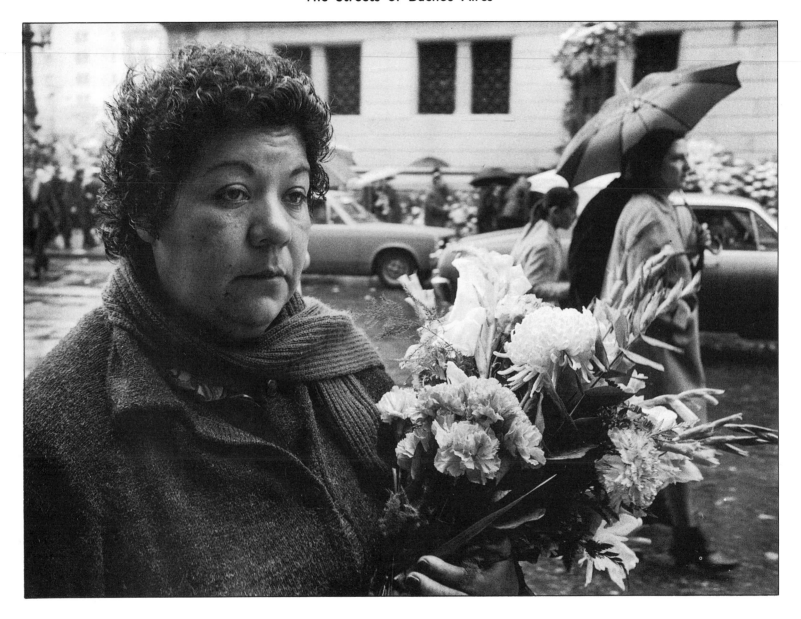

Funeral of President Perón, 1974

Funeral of President Perón, 1974

Plaza Lavalle, 1978

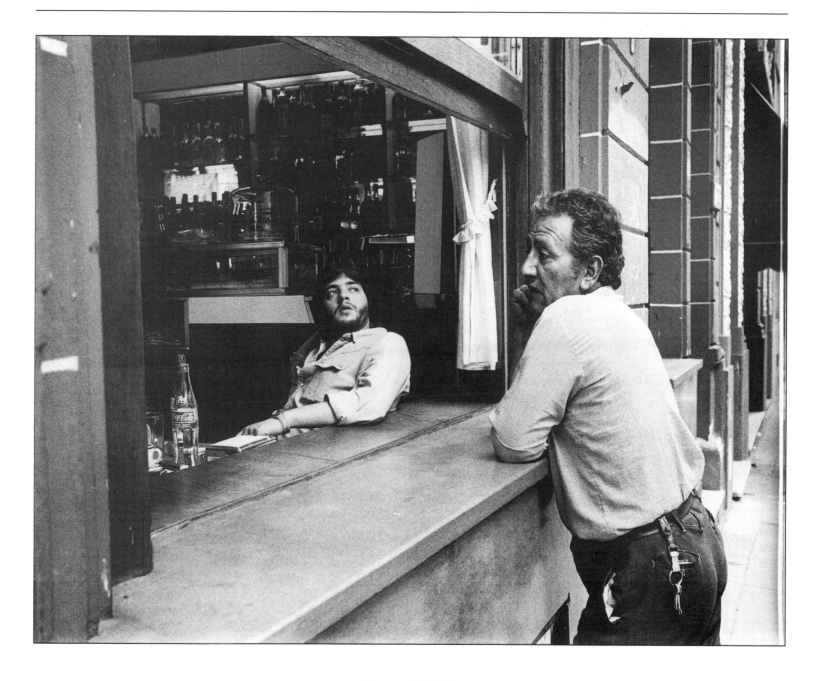

Corner café, 1990

Jorge Luis Borges, 1968

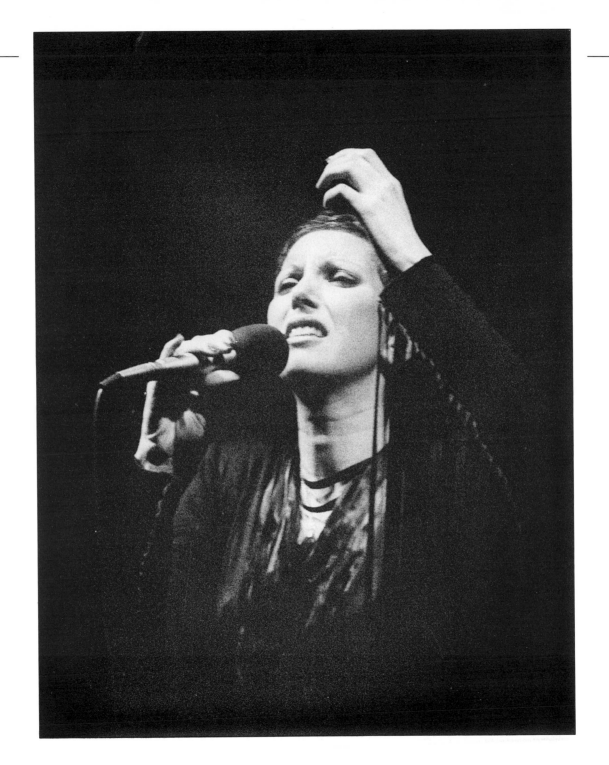

Susana Rinaldi, Tango Singer, 1978

Myself in Buenos Aires, 1978

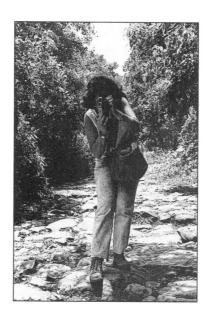

Graciela Iturbide

(MEXICO)

This series on the *cholos*, Mexican street gangsters operating both
sides of the US border, grew out of a project on 'La Frontera'. The
photographer lived the daily life of the *cholos* who, unassimilated
into the rest of society, devise their own styles of living.

I come from a family of thirteen children, with lots of different interests. My father, who was a photographer, gave me a Kodak 'Box Brownie' for my twelfth birthday and I started taking snapshots for fun, without thinking of 'becoming a photographer'. Because there were so many of us, we always seemed to be taking pictures of one another.

Much later on in 1969, after marrying and having children while still young, there was an opportunity for me to study cinematography. I left after three years of a five-year course, and spent a year and a half as photographic assistant to Manuel Alvarez Bravo. I'm not sure what it means to 'turn professional'. All I know is that since then I've been self-taught. Everything I photograph is drawn from my life and in some sense therefore out of my childhood. From the start taking pictures has charmed me, it's something I actively enjoy. I particularly love coming to know my country through the lens of a camera.

I work every day of my life, I work very hard and that's the way I like it. If I'm not travelling and photographing, then I'm working in my darkroom. I process virtually all my own work. Of course the pressure to be earning money is always there, but it's a pressure I tend to disregard. Somehow I get by, thanks to grants and commissions, often from European or North American foundations. Since there's little of that kind of assistance in Mexico, I tend to travel a great deal. For me travel is inseparable from looking and photographing although I tend to like to travel best in Latin America. But my influences are not local ones: I'd name among the most important the Czech photgrapher Koudelka, the Brazilian Sebastião Salgado, the Hungarian Kertész, the Spaniard Cristina García Rodero and of course Cartier-Bresson. From this you can see that Europe is an important source of inspiration, and I visit it fairly regularly. Also one of my sons, a musician, now lives in

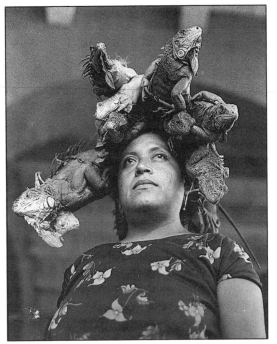

Our Lady of the Iguanas, Juchitán, 1979

Paris. My other son is an architect and lives in Mexico City, though no longer with me.

You only need a minimum of money to keep on working, and now that my sons are grown up I have what feels like a considerable freedom. I just have my three Leicas to maintain! I've never been without work, it just seems to keep on coming in although, obviously, I prefer to select my projects. As you can see, I also prefer working in black-and-white, I don't know why really. I use colour on commission, as in the recent book on cemeteries. But for me, colour can be too pretty; black-and-white is closer to my own sense of reality.

As to the question of my style, I'm not sure if it's for me to say. I firmly believe that photography is a reflection of the photographer, even of their state of being at the time the image was shot. I don't know if you'd call my work 'art' photography, perhaps some of it is. What matters more to me are themes involving the dignity of human beings and the life of my country. I want each of my photographs to contain a little of what it is to belong to humanity, and to say it with poetry. There are certain people and situations I would avoid photographing, for example when conditions have become so bad that the dignity and so the poetry is lost. I prefer to find circumstances where people, however marginalized, retain their identity, which means their dignity. There's a political dimension too, that for me has always been important, but I'd rather be thought of for the poetry rather than the politics of my photographs.

If I hadn't been a photographer, I would like to have been a writer, something I'd decided on when I was a child. I especially liked reading translations of Nahuatl poetry, but my family was very conformist and opposed my studying philosophy and literature. Cinema and photography were what emerged at a later point in my life, but my first love happened to be literature. Maybe that's why I look for a poetic aspect

to my work now and why I consider it to be informed by poetry. Of course that's a subject with far wider dimensions: the myths of all humanity intersect at some point, it's only their expression that's culturally determined. I'm fascinated by the mystic element, and believe that all experience can be put to creative use. In that sense I'm at one with our indigenous peoples when they say there is no difference between what we do and

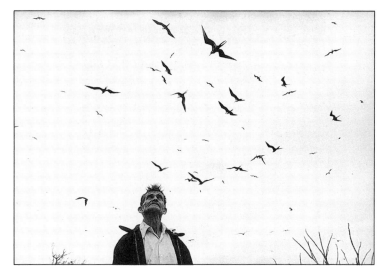

Lord of the birds, 1985

be purely about women. Rather, as soon as I went to Juchitán, it was obvious that I was in a matriarchal society where women run the economy as well as the home. They are the inheritors of a long and proud Zapotec tradition — the women fought the conquistadores too — and are still a formidable force in Oaxacan politics: the leaders of both main parties are women. Yet we bring our own prejudices to looking at and describing pictures: 'Our Lady

what we dream, our desires and our lives. During my career, I have photographed a number of different indian communities, often concentrating on the religious syncretism of Catholicism and far older precolumbian traditions. I'd still love to spend time in Cuba and cover the celebrations of *santería*. The series on the Seri [for the book *Sueños de Papel/Paper Dreams*] takes the 'people of the sand' and follows their daily life — which incorporates all the aspects I've described. I've also recently spent a couple of months with the Tarahumara cave-dwellers for a new project that focuses particularly on death, which obviously connects with this 'mystic element' I like. In this I've finally moved slightly away from my obsession with human beings and include animals, or the relationship between the two. I'm not a believer myself, but I want to know about people's attitude to death, the rôle that animal sacrifice still plays, this fantasy we all have with visiting the cemetery on All Souls' Day. I always try to persuade the people there to tell me everything, read as much as I can, to begin to understand how their beliefs and legends are incorporated into Catholic practices. Often their lives are on the borderline yet these people have their own kind of magic there in their fiestas.

I don't set out with a preference for only photographing old or young or marginalized people. It's even true to say that when I photographed *The Women of Juchitán* it wasn't a project intended to

of Juchitán' has also been called 'The Juchitán Medusa'. In fact she's a marketeer taking the live iguanas she's caught to sell for food. But she too likes the titles we've given her, and has her portrait on the mantel that is her hearthside altar. Very suitable for an 'Our Lady . . .'!

My present work also includes the *cholos*, the street gangs that operate both sides of the North American border. Their culture is a mixture of US and Mexican, with a lot of nostalgia for their country of origin, which is why there are so many graffiti, so many tattoos of the Virgin of Guadalupe. These are people horribly mixed up in the drugs business, one consequence of their marginalization between the two cultures. They're the descendents of the *chicanos* who worked the land for its North American owners and generally died young and poor in the process. Some of this generation are rebels and bandits, each gang with their own uniform to identify themselves. The *cholas* particularly caught my attention because being women and deaf-and-dumb too marks them out as multiple outcasts.

The *cholas* project came out of a commission on 'A Day in the Life of Los Angeles' for a larger undertaking with other photographers on 'A Day in the Life of America'. I've never lived in LA, but I made contact with the gang through a *chicana* painter, a friend whose daughter is a member. Later the San Diego Museum of Photography asked me to expand this day's work as part of a series of 'frontiers' and

this fascinated me. The *chola* women are all unemployed, one has a baby, they go to the park and buy drugs. All of them say they're acultural and apolitical, but to me they still have a lot in common with Mexico and with Latin America: language and religion for a start. Only Brazil, with its other language and influences, is a world apart from the rest of Latin America.

To me being apolitical isn't an option, even without believing in 'pamphleteering'. I've long located

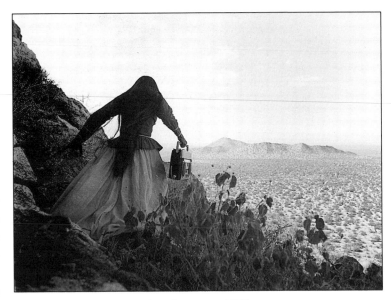

Angel woman, 1979

myself on the left and have done a lot of work that's politically connected — photographing, for example, Cuauhtemoc's presidential bid against the Party of the Institutionalized Revolution, in power for over sixty years. Or in documenting General Torrijos of Panama, following him on his journeys and his meetings with the people of his country. Torrijos was an enormously popular president, whose term of office was cut short, apparently by a bomb on board his aeroplane.

It's important to be in touch with what's happening in other parts of the world; another of the projects I particularly enjoyed was working with unemployed women at the Side Gallery in Newcastle in 1988, and photographing that part of England.

I've done nothing to avoid photojournalism, documentary or reportage photography. I don't consider that they amount to much more than taking photographs in the street, which is what I and a great many other photographers do. I don't generally work for newspapers, though they and magazines sometimes use my work. At times I even take pictures of landscapes, but the only kind I enjoy are fierce, never pretty! I've been doing some work showing goats being killed, their corpses cut and cured in the sun. I take pictures of goats grazing in fields too, but for me that's never the end of the story . . .

Increasingly I've come to believe that there *are* differences

between the work of male and female photographers. Looking through the work of a large number of women, myself included, I recognize that we take pictures according to our own outlook, a 'female' one. This doesn't make it impossible for a woman to photograph 'like a man' or vice versa, or that a male photographer doesn't use sensitivity and delicacy. But our own relationship to the world, our position in society and as mothers, often conditions us differently from men. At times this is an asset: it can be a passport to approaching certain groups such as the Juchitán matriarchs or the Californian *cholas*. And I think the result shows in an implicit femaleness in our work, a consequence of our status as women.

All this influences me as much as talking about Mexican 'photographic traditions'. Even without our culture I'd say that what I see and read, in particular anything to do with popular arts and religion, is at least as relevant as purely photographic influences. At the moment I'm working on a theme connecting death and fiestas, perhaps because as human beings we all have to come to terms with death. Whatever takes place in Mexico seems to require a fiesta, so I'm following the Holy Week fiestas, the Patron Saints' Days, the Day of the Dead celebrations in different places. I'm trying to treat it all in, well, a Biblical manner. I'm not yet sure where this is taking me, I never know in advance as it can take me in many different directions. I've begun, however, with the twin themes of angels and sacrificial animals.

In general, as in this instance, I do the work I want to do. I invariably come up with the funding or with a scholarship. However, I never accept work for advertising agencies or anything remotely related. Doing books often gives me the greatest freedom because they

afford me the most time. Right now I've done so much work in Europe, particularly with gypsies in Galicia and Portugal, that I'm glad to be home again and have no plans for further trips. It's usually when I'm awarded a prize or a foreign exhibition that I get to go abroad. For now, I've more than enough to occupy me here. I nearly always work alone, although sometimes as part of a wider project, such as that on the 'frontiers', funded by the Guggenheim Foundation, on which I covered my own particular area. On the occasions when I've worked with men, I've not found that maschismo has been a problem. We're generally engaged in the same project with a common aim, and there's far too much ground to be covered.

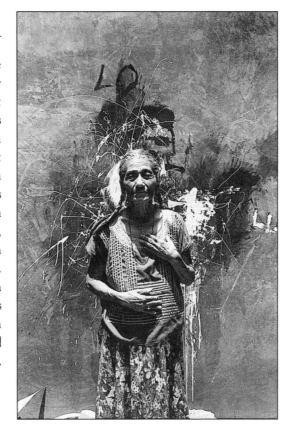

The old woman of Toledo, 1988

As for my audience, how can I say what I'd like them to see, when each one will see something different? But I would like them to *feel* something. If only I could touch the people who see my images. What I'd like them to feel is a bit of what I felt myself in creating that work, what I lived through with the subjects of those images, even though I realize that's a tall order. I photograph people because I'm a person — and so is each viewer. And when a series is completed, I think the audience will see that it's both about the subject and also about myself, that it involves a double-image. At this point a third party enters the equation who is you, looking at what you can and want to see, now at this moment in time.

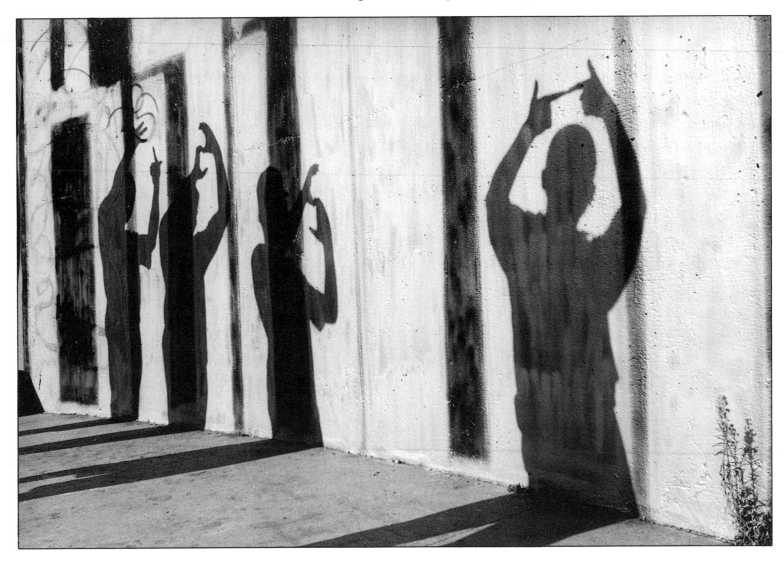

'Harpys', East L.A., 1990

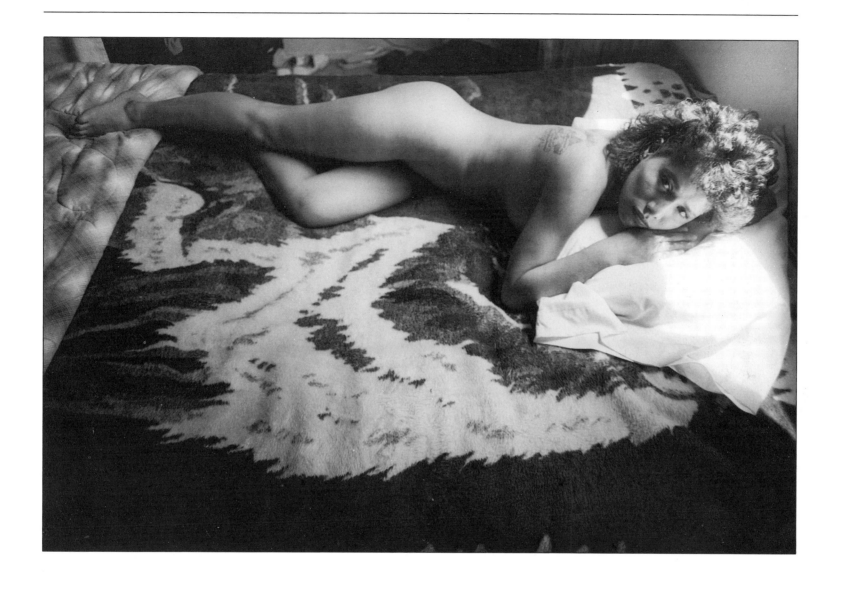

Cristina, East L.A., White Fence, 1986

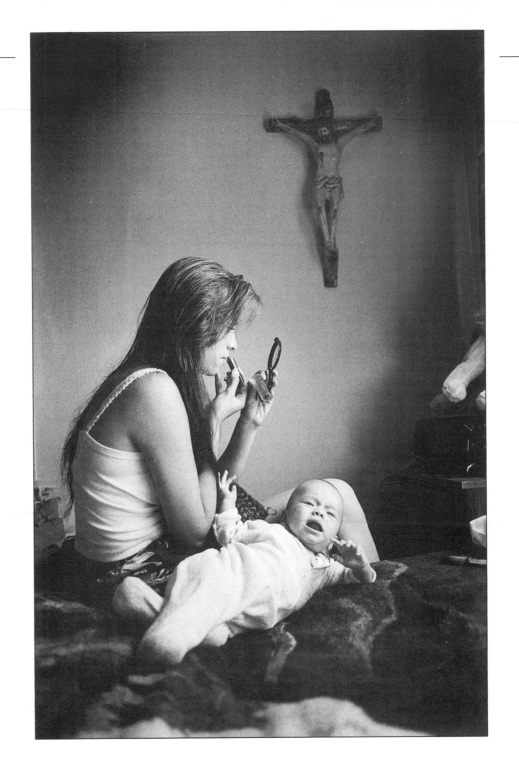

Rosario getting ready to go out, 1986

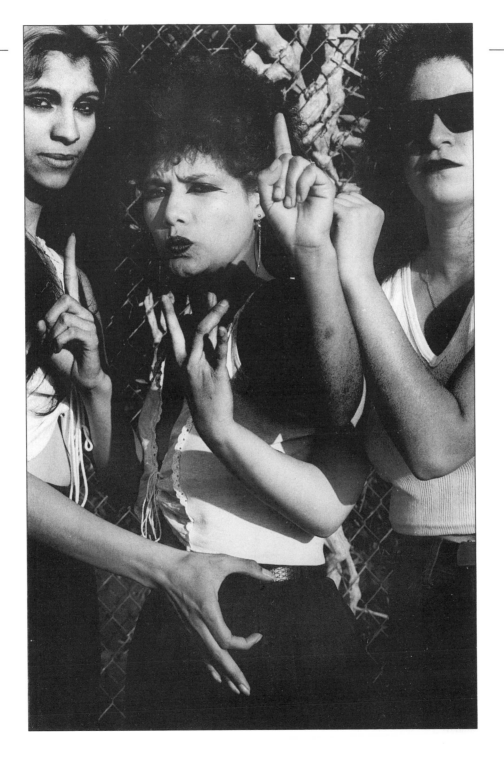

Rosario, Liza, Cristina, East L.A., 1986

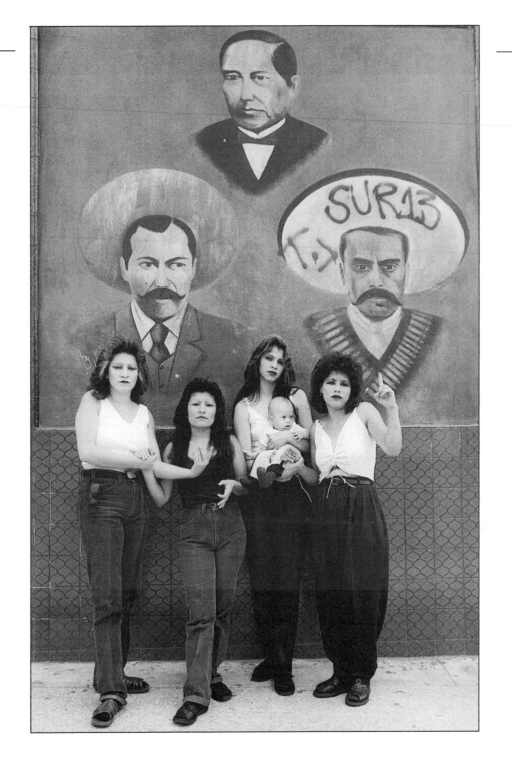

White Fence, 1986

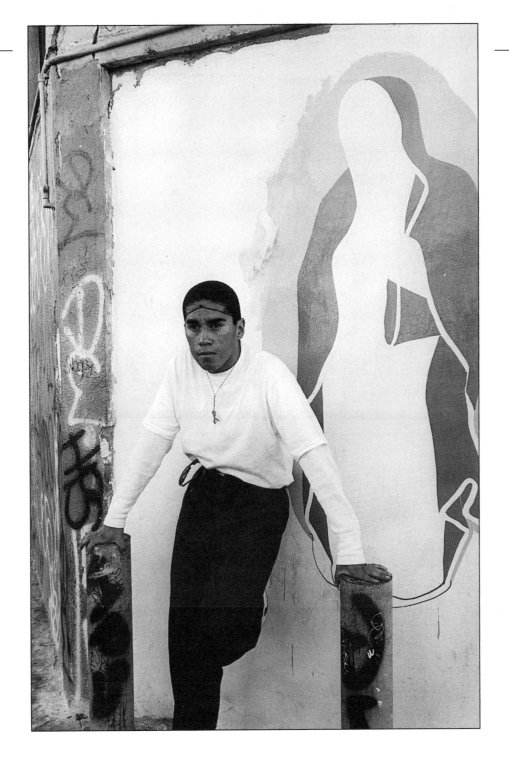

'Harpys', East L.A., 1990

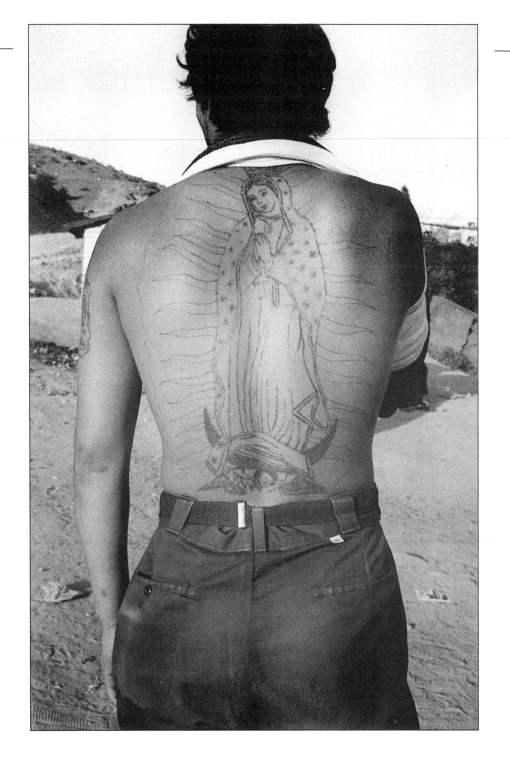

The Frontier, Tijuana, 1990

Biographies

Elena Poniatowska

Elena Poniatowska is a journalist, novelist and short-story writer at the forefront of contemporary Latin American writing. Some of her principal works of non-fiction include *La Noche de Tlatelolco* and *Fuerte es el Silencio* and of fiction *Lilus Kikus*, *Hasta no verte Jesus mío* and *De Noche vienes*. She has also introduced books by major Mexican photographers such as Graciela Iturbide and Mariana Yampolsky.

Sandra Eleta (Panama)

Further education
Photographic studies in Panama City and at Finch College and the New York School of Social Research and the International Centre of Photography, USA.

Principal shows
Centre for Inter-American Relations, New York, USA, 1975
The Latin Woman, Instituto de Arte Contemporáneo Hispánico, Rockefeller Centre, New York, USA, 1976
Rhos y Minorís, Galería Fotocentre, Madrid, 1978
Primer Coloquio de la Fotografía, Mexico City, 1978
Venezia '79/la Fotografía, Venice, 1979. Travels to Canon Photo Gallery, Amsterdam and les Rencontres d'Arles
Retrospectivas, Caracas, Venezuela, 1980
Segunda Muestra de Fotografía Latinoamericana, Bellas Artes, Mexico City, and at Zurich, Switzerland 1981
Portobelo, Museo de Arte Contemporáneo, Panama City, 1982
Fotografie Lateinamerika 1960–1980, Akademie der Kunst, Berlin and Centre Georges Pompidou, Paris, 1982
Portobelo, Agathe Gaillard, Paris 1983
Retrospectivas, Nikon Photogalerie, Zurich, 1984
Tercera Muestra de la Fotografía Latinoamericana Contemporánea, Museo Nacional de la Habana, Cuba, 1984

Latin American Photography, Aperture Foundation Centre, New York, 1987
Latina, City Gallery, New York, 1988
Festival de Tres Mundos, Nantes, France, 1989
Enucentro Fotográfico de America Latina, Quito, Ecuador, 1990
Recontres d'Arles, Arles, France, 1991

Principal collections
Bibliothèque Nationale de Paris, France
Museo de Arte Moderno, Mexico City
Kunsthaus, Zurich, Switzerland
Art Institute of Chicago, USA
Museo de Arte Contemporáneo, Panama
George Eastman House, Rochester, USA

Publications
Solentiname, (with poems by Ernesto Cardenal), Nicaragua 1978
Hecho en Latinoamérica, Mexican Council of Photography, Mexico City, 1978
Kunsthaus, Fotografie Lateinamerika, Zurich, Switzerland, 1981
Portobelo, Buenos Aires, 1985
Latina, New York, 1988

Videos
Sirenata en B, shown at the National Cultural Institute, Panama; the Buenos Aires Cultural Centre; the Joseph Rapp Theatre, New York; Casa de las Americas, Havana; and the Arles Recontres, 1985
El Imperio nos Visita Nuevamante, Panama City, 1990; Arles 1991
Panama Audiovisual, Expo '92, Seville

Prizes and awards
Photographic Personality of the Year, Panama City, 1982
Hija Meritoria, Portobelo, Panama, 1985
Excelencia Técnica y Artística/Sirenata en B, Panama City, 1985. Also the New York Crystal Apple Award for Best Original Photography on the same video, 1985

Diploma in Recognition of the Contribution made to the Progess and Prestige of Panamanian Culture, Panama City, 1988
Photographic Encounters of Latin America prize, Quito, Ecuador, 1990
Maxell Video Prize, Panama City 1990

Guggenheim Memorial Foundation Fellowship, USA, 1986–8
European Economic Community Prize for *Women Seen by Women*, Venezuela, 1989
Grant from the Andes Foundation, Santiago, for work in progress, 1990

Paz Errázuriz (Chile)

Further education
Cambridge Institute of Education, England; BA in Education from the Catholic University of Chile. Self-taught in photography.

Principal one-woman shows
Personas, Institute Chileno Norteamericano de Cultura, Santigo, 1981
Fotografías 1982, Galería Sur, Santigo, Chile, 1982
Entreactos, Bio-Bio University, Concepción, Chile, 1983
Fotografías, Galerí Carmen Waugh, La Casa Larga, Santiago, 1986
Combate contra el Angel, Galería la Plaza, Santiago, Chile 1987
De a Dos, Galeria Carmen Waugh, Santiago, 1988
Adam's Apple, Centre for Photography, Sydney, Australia, & Galería Ojo de Buey, Santiago, Chile, 1989
Un Cierto Tiempo, Museo Nacional de Bellas Artes, 1991

Publications
Amalia (children's story, text and photographs by Paz Errázurìz), Santiago 1973
Amor de Errázuriz-Fotógrafo (text Patricio Marchant), Santiago, 1983
La Manzana de Adán (text Claudia Donoso), Santiago 1990
Un Cierto Tiempo (UNICEF calendar), 1990

Included in
Paz Errázuriz, photographer: Women Artists in Chile, the Conscience of a Country in Crisis (text by Marjorie Agosín), Washington 1984
A Marginal body: the Photographic Image in Latin America (text by Charles Merewether), Sydney, Australia
Chile Seen from Within, North Publications, 1990

Honours and awards
Prize for entry on *The Child in Latin America and the Caribbean*, UNICEF, Santiago, Chile 1981
Prize for entry on *The Chilean Family*, Vicaria de la Solidaridad, Chile, 1982
Prize for entry on *The French Presence in Chile*, Santiago, 1983

María Cristina Orive (Guatemala)

Further education
BA in Communication Studies, Smith College, USA. Further studies in English and French and print journalism. Self-taught in photography.

Principal exhibitions
Hecho en Latinomamérica, Museo de Arte Moderno, Mexico DF, 1978
Venezia '79/la Fotograifa, Venice, Italy and Quito, Ecuador, 1979
Actos de Fe en Guatemala (with Sara Facio), Agathe Gaillard, Paris 1981
Fotografie Latinoamerica 1860 bis Heute, Zurich Kunsthaus; Museo de Arte Moderno, Madrid; 1981
Coloquio Latinoamericano de Fotografía, Bellas Artes, Mexico City, 1981
Fotografía Argentina Contemporánea, Milan Biennale di Caserta, 1982
Autoretratos, Omega Gallery, La Plata, Argentina 1982
Photo-America 1984, Genova, Italy, 1984
El Sereno, Antigua, Guatemala, 1985
Retrospectivas, San Martín, Buenos Aires, 1988
Cent Ans de Photographie au Guatemala, Maison de l'Amérique Latine, Paris, 1990
Recontres Internationales de la Photographie, Arles, France, 1991

Principal publications
Photo-reportage for *Primera Plana* Buenos Aires, 1969
Photo-reportages for ASA, SIPA and GAMMA press agencies, Paris 1969–82
Actos de Fe en Guatemala (with Sara Facio, text by Miguel Angel Asturias), Buenos Aires, 1980

Also publishes other photographers' work and curates their shows, including:
Recontres Internationales de la Photographie, Arles, 1979
Andre Kertész, Bellas Artes, Buenos Aires, 1979
Libros Fotográficos de Autores Latinoamericanos, Carrillo Museum, Mexico City, 1981
La Antigua Guatemala: J.J. Yas and J.D. Noriega 1880–1950, Buenos Aires, 1990; exhibition at the Maison d'Amérique Latine, Paris

Sara Facio (Argentina)

Further education
Qualifies as a teacher of painting at the Fine Arts Institute, Buenos Aires. French government award to study art history in Paris. Apprenticed to Luis D'Amico, then Annemarie Heinrich, to learn photography. Scholarship to study colour processing at the Kodak Laboratories, USA.

Principal exhibitions
Argentine Writers, Buenos Aires, 1963
Tiempo de Fotografía, Buenos Aires, 1966
Retrospectivas, Museum of Modern Art, Mexico City and Friendship House, Moscow, 1978
Venezia '79/la Fotografia, Venice, Italy, 1979
Les Recontres, Arles, France 1979
Retratos y Autoretratos, National Historical Institute and Art Centre, Buenos Aires, 1980
1981: Touring exhibition at Agathe Gaillard, Paris; The Photographers' Gallery, London; Museum of Modern Art, Sâo Páolo, Brazil; Tsukada Gallery, Japan; Palace of Fine Arts, Mexico City; Kunsthaus de Zurich, Switzerland; Museum of Modern Art, Buenos Aires
1982: Touring exhibition to Santa Fé, Argentina; Museum of Sound and Image, Brazil, Friendship House, Germany
Portraits of Latin American Writers at the *Recontres*, Arles, 1991
Las Hechiceras, Gallery K61, Amsterdam and Berlin 1991
Retrospectivas, Centre Georges Pompidou, Paris 1992

Principal publications
Buenos Aires-Buenos Aires (text by Julio Cortázar), Argentina, 1968
Geografía de Pablo Neruda (manuscript texts by Neruda), Spain, 1973
Retratos y Autoretratos, (manuscript text from twenty-one Latin American writers), Argentina, 1974
Como Tomar Fotografias (How to take Photographs), Argentina, 1976
Humanario, (text by Julio Cortázar), Argentina, 1977
Actos de Fé en Guatemala (with María Cristina Orive; text by Miguel Angel Asturias), Argentina, 1980
Fotografía Argentina Actual (selected and introduced by Sara Facio), Argentina, 1981
Sara Facio and Alicia D'Amico: Fotografia Argentina 1960–85, (text by María Elena Walsh), Argentina, 1985

Graciela Iturbide (Mexico)

Further education
Studied cinema in the Mexican national university Centre of Cinematographic Studies (UNAM). Photographic apprenticeship to Manuel Alvarez Bravo. Since 1974, fulltime photographer. Member of the Mexican Salon of Plastic Arts, the Forum of Contemporary Art and the Mexican Council of Photography.

Principal one-woman shows
Graciela Iturbide, Musée d'Art Moderne, Centre Georges Pompidou, Paris, 1982
Juchitán, Casa de la Cultura de Juchitán, Oaxaca, Mexico; Musée Cantonale de Belles Arts, Lusanne, Switzerland, 1987. Tours Mexico 1988–90
Graciela Iturbide, Centro Ricerche per l'Immagene Fotografica, Milan, 1987
Juchitán, Pueblo de Nube, Side Gallery, Newcastle, 1988; Mexico Cultural Centre, Paris, 1988; Camerawork, London, 1989; Hokaido, Japan, 1990; Museo de la Recoleta, Buenos Aires, 1989
Encuentros Internos, Imágenes Externas Museum of Modern Art, San Francisco, 1990
Neighbors, Museum of Photographic Arts, San Diego, 1990
Old World, New World: The Hispanic Photographers, Seattle Art Museum, 1991
Retrospectiva, Recontres d'Arles, 1991
The Legacy of E. Smith, Centre Georges Pompidou, Paris and Institute of Contemporary Photography, New York, 1991

Publications
Catalogues of numerous groups shows, produced in Europe, the Americas, the Caribbean, the Soviet Union, from 1978
Los que viven en la Arena, Instituto Nacional Indígenista, Mexico 1981
Sueños de Papel, Fondo de Cultura Económica, Mexico 1985
Juchitán de las Mujeres, text by Elena Poniatowska, Mexico 1989
Médecins San Frontières, Toulouse, France, 1991

Collections
Graciela Iturbide's work is in numerous private and public collections including –

Bert Hartkamp, Amsterdam, Holland
Bibliothèque Nationale, Paris, France
Casa de las Americas, Habana, Cuba
Casa de la Cultura, Oaxaca, Mexico
Center for Creative Photography, Tucson, Arizona, USA
Franco Fontana, Milan, Italy
Consejo Mexicano de Fotografía, Mexico
Musée d'Art Moderne, Paris, France
Riverside Museum of Photography, California, USA
Parma University, Italy

Prizes and awards
Primera Bienal de Fotografía, INBA, Mexico, 1980
Photographic Essay Award, Mexico, 1983
International Labour Organization Prize for *Labour and Unemployment*,
 Santiago, Chile, 1986
W. Eugene Smith Memorial Foundation, New York, USA, 1987
Guggenheim Fellowship for *Fiesta and Death in Mexico*, 1988
First Prize in *Le Mois de la Photo*, Paris, 1988
Hugo Erfurth Prize, Leverkusen, Germany, 1989
First International Prize, Hokaido, Japan, 1990